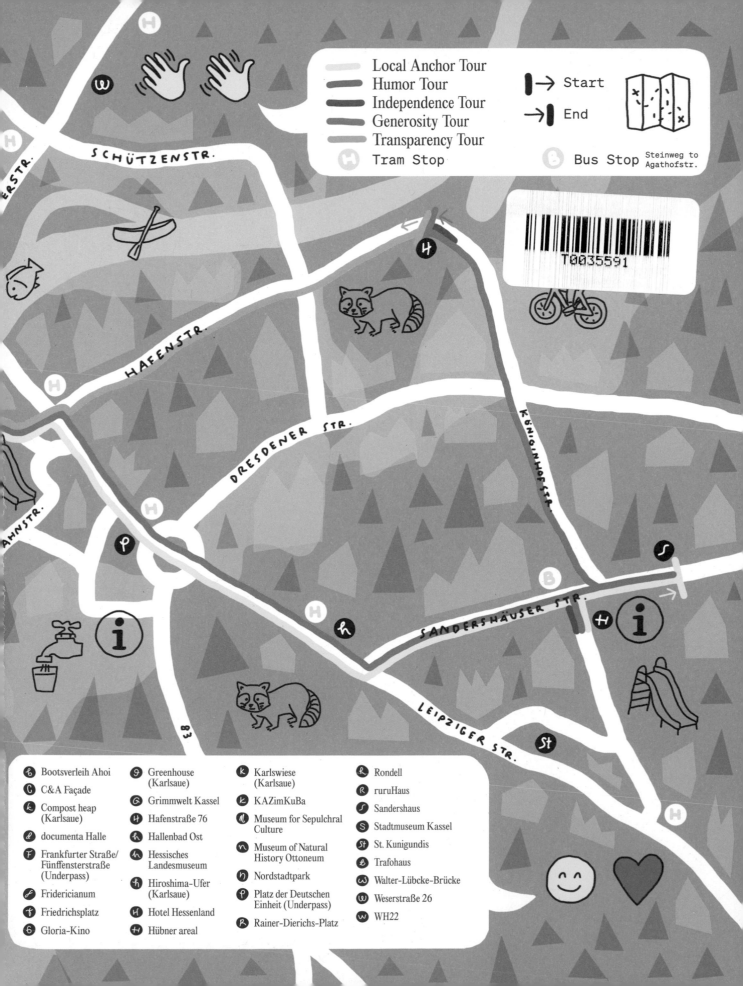

Legend

- Local Anchor Tour
- Humor Tour
- Independence Tour
- Generosity Tour
- Transparency Tour
- Ⓗ Tram Stop
- ▮→ Start
- →▮ End
- Ⓑ Bus Stop — Steinweg to Agathofstr.

T0035591

Street names:
- SCHÜTZENSTR.
- ...ERSTR.
- HAFENSTR.
- DRESDENER STR.
- KÖNIGINHOFSTR.
- ...AHNSTR.
- SANDERSHÄUSER STR.
- LEIPZIGER STR.
- 83

Location index:

- ⓑ Bootsverleih Ahoi
- Ⓒ C&A Façade
- Ⓚ Compost heap (Karlsaue)
- ⓛ documenta Halle
- Ⓕ Frankfurter Straße/ Fünffensterstraße (Underpass)
- ⓕ Fridericianum
- Ⓕ Friedrichsplatz
- Ⓖ Gloria-Kino
- ⓖ Greenhouse (Karlsaue)
- Ⓖ Grimmwelt Kassel
- Ⓗ Hafenstraße 76
- ⓗ Hallenbad Ost
- ⓗ Hessisches Landesmuseum
- ⓗ Hiroshima-Ufer (Karlsaue)
- Ⓗ Hotel Hessenland
- Ⓗ Hübner areal
- Ⓚ Karlswiese (Karlsaue)
- Ⓚ KAZimKuBa
- Ⓜ Museum for Sepulchral Culture
- Ⓝ Museum of Natural History Ottoneum
- Ⓝ Nordstadtpark
- Ⓟ Platz der Deutschen Einheit (Underpass)
- Ⓡ Rainer-Dierichs-Platz
- Ⓡ Rondell
- Ⓡ ruruHaus
- Ⓢ Sandershaus
- Ⓢ Stadtmuseum Kassel
- Ⓢ St. Kunigundis
- Ⓣ Trafohaus
- Ⓦ Walter-Lübcke-Brücke
- Ⓦ Weserstraße 26
- Ⓦ WH22

KASSEL

To walk, discover and share Kassel with others, we offer you two maps. On the front map we see five tours marked, which at the same time show some activities and special places in the city.

A second—blank—map is located at the end of the book, so you can draw in your experiences and adventures.

KEY FOR STICKERS

Information, experiences and places marked on the map

 Bench Playground

 Cycle path Public library

 Boat tour Watering point

 Fish Public bathroom

 Flower field Racoon

 Information Stairs

 Panorama view Skate park

 Picnic area Swimming place

 Post office

Services available at documenta fifteen venues

 Information

 Tickets

 Coat check

 documenta fifteen publications

 Books & Goods

 lumbung Kios

 lumbung Press

 Food and drinks

 Lost and found

 Meeting point for exhibition walks

 Bathroom

 Barrier-free bathroom

 Baby changing table

 Barrier-free washroom

VE~~UES

MITTE

C C&A Façade
Obere Königsstraße 35

d documenta Halle
Du-Ry-Straße 1

F Frankfurter
Straße / Fünffensterstraße
(Underpass)

f Fridericianum
Friedrichsplatz 18

f Friedrichsplatz

G Gloria-Kino
Friedrich-Ebert-Straße 3

G Grimmwelt Kassel
Weinbergstraße 21

h Hessisches Landesmuseum
Brüder-Grimm-Platz 5

H Hotel Hessenland
Obere Königsstraße 22

k KAZimKuBa
Rainer-Dierichs-Platz 1

M Museum for Sepulchral Culture
Weinbergstraße 25–27

n Museum of Natural
History Ottoneum
Steinweg 2

R Rainer-Dierichs-Platz

R ruruHaus
Obere Königsstraße 43

S Stadtmuseum Kassel
Ständeplatz 16

W WH22
Werner-Hilpert-Straße 22

FULDA

b Bootsverleih Ahoi
Blücherstraße 22A

w Walter-Lübcke-Brücke

g Greenhouse (Karlsaue)
Coordinates
51.300310, 9.498459

H Hafenstraße 76

h Hiroshima-Ufer (Karlsaue)

k Karlswiese (Karlsaue)

k Compost heap (Karlsaue)
Coordinates
51.298472, 9.493083

R Rondell
Johann-Heugel-Weg

BETTENHAUSEN

h Hallenbad Ost
Leipziger Straße 99

H Hübner areal
Agathofstraße 15

P Platz der Deutschen Einheit
(Underpass)

S Sandershaus
Sandershäuser Str. 79

St St. Kunigundis
Leipziger Str. 145

NORDSTADT

n Nordstadtpark

w Weserstraße 26

t Trafohaus
Lutherstraße 2

WALKING FINDING SHARING

A GRAPHIC COMPANION TO DOCUMENTA FIFTEEN

CARMEN JOSÉ
JULIA KLUGE
MALWINE STAUSS
NADINE REDLICH
RITA FÜRSTENAU
ISABEL MINHÓS MARTINS
BERNARDO P. CARVALHO
JULES INÉS MAMONE (FEMIMUTANCIA)
VERÓNICA GERBER BICECCI
INNOSANTO NAGARA

HATJE
CANTZ

INTRODUCTION

The book you hold in your hands is very special to us. It could become special to you too. It's an illustrated book about lumbung values for shared experience and discovery.

lumbung is Indonesian for granary. A traditional farm building that many cultures, not only the Indonesian, use to store their crops, to meet and discuss who needs how much of the grain when, and to come together in celebration of the collective harvest.

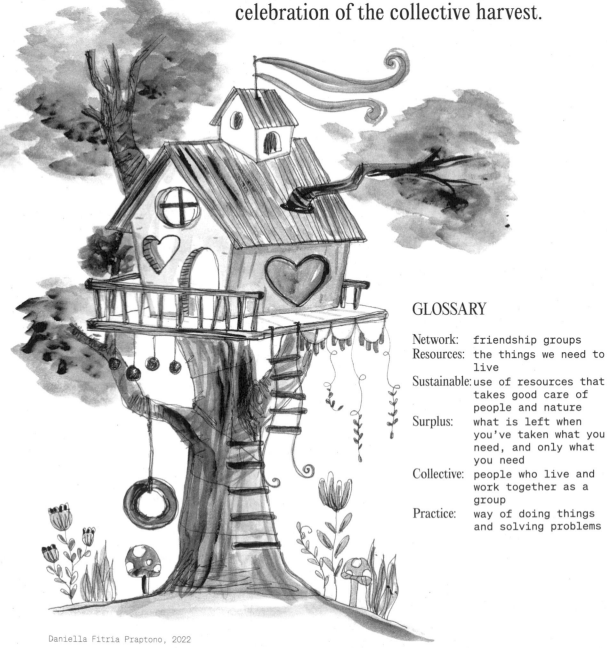

GLOSSARY

Network:	friendship groups
Resources:	the things we need to live
Sustainable:	use of resources that takes good care of people and nature
Surplus:	what is left when you've taken what you need, and only what you need
Collective:	people who live and work together as a group
Practice:	way of doing things and solving problems

Daniella Fitria Praptono, 2022

We write lumbung like this: lumbung. Even after a full stop! lumbung, to us, is the space where art meets social activism, business, and local friendships. It is a space for figuring out what is happening in the environment that surrounds us so that we can respond to it. It is a space for action, for starting something together that makes sense where we live and practice.

As the Artistic Team behind documenta fifteen, we want to answer the question: How can we use this world exhibition in Kassel, Germany to build a space where art can live and give something back to the different environments that surround artists from around the globe? Not just for now but for a long time to come. How can we make sure this space is sustainable? Which ways of doing things will we have to develop together? If we have more than we need as artists, how can we share what we have?

These questions are at the heart of lumbung practice and lumbung values, of doing and being lumbung. Having worked in collectives for many years and in many countries, we called upon our friends to help us. Collectives of artists who are like us but also totally different. Often struggling to survive.

If you must fight to keep doing what you're doing year in and year out, in the end you get to know a lot of tricks and knacks for getting by. Knowledge like this is a surplus that can be shared and help others to survive. But of course, one can also share other things such as money, time, recipes, spaces, and art.

We needed to find out how to build our lumbung to store all this and make it last. To start with, who should be in it and in the exhibition with us?

Like we said, we come from many different places ourselves, so we could talk to collectives in our own networks and then to those in their networks or ekosistems. But how to choose? By seeing the values that we share and find important to practice. In this book you find five of them, but we have many more!

The five are *Local Anchor* for staying grounded in your community, *Humor* for joy and to communicate about difficult things, and *Independence* to resist outside pressures to follow plans that are not yours. Caring about the wellbeing of others and sharing not just to get something in return is the value of *Generosity,* and *Transparency* is for showing others what you do and that they can trust you.

After nongkrong'ing with many collectives, we invited 14 to join what we call lumbung inter-lokal. If international means you leave home and meet other inter-nationals, inter-lokal means you remain rooted in your own place and meet with others to share re-sources that will nurture your community at home. More than 50 artists have since joined us and met in something called majelis to experiment with

Ade Darmawan, 2022

6

putting exhibition budget and space into a collective
pot and sharing them.

You'll find all the lumbung members and artists in
the five tours in this book.

> Ekosistem, nongkrong, and majelis also come from
> Indonesian and mean ecosystem or lives that are
> connected, hanging out and telling stories, and meeting
> with a purpose of some sort. Now that we have ex-
> plained the words and values that we use to you, they
> are also yours. And when they are yours, you can also
> share them with others.

lumbung can be used in more ways than a Swiss army
knife! We've used it to invite our friends from consonni,
a collective of publishers who live and work in the
Basque country, to make this book with us and dif-
ferent amazing authors.

You can use it in Kassel during documenta fifteen to
explore the exhibition and the city that surrounds it.
But it is just as valuable wherever and whenever you
might happen to read the book, if you look for the
lumbung values inside and around you.

```
        Have lots of fun
        walking, finding, sharing!
```

ABOUT THIS BOOK

HOW TO READ AND WALK EACH TOUR?

We suggest you read the stories of this book in company and collectively walk the routes they propose. If you're in the mood, we suggest that you surround yourself by family members; by real or imaginary friends of all ages; by workmates, schoolmates, activist friends, or people you've met on the bus or the train. And if you read or walk on your own, that's no problem; with every step forward or back, we'll be with you, and you might even make friends along the way. Our routes are meant as suggestions. You can walk them exactly as they are proposed or only parts of them, but you can also combine them, or even find your very own tour!

WHO MADE THE STORIES AND TOURS?

In order to make this book and show the routes to you, we joined forces with accomplices from many different parts of the world. They are outstanding illustrators writing with images, and sharing ideas through stories: Rotopol in Kassel (Carmen José, Julia Kluge, Nadine Redlich, Malwine Stauss and Rita Fürstenau); from Portugal, Isabel Minhós Martins and Bernardo P. Carvalho; from Argentina, Jules Inés Mamone (Femimutancia); from Mexico, Verónica Gerber Bicecci, and Innosanto Nagara from USA/Indonesia.

HOW WERE THE STORIES AND TOURS MADE?

We gave each illustrator a number of ingredients. First, we selected five lumbung values *(Local Anchor, Humor, Independence, Generosity,* and *Transparency);* then we shared with them the preliminary proposals of the individual artists and collectives participating in documenta fifteen, and finally information about the venues that would house the projects. With these ingredients, and based on their own style and where they come from, the illustrators came up with their own personal interpretations of documenta fifteen and how to immerse ourselves in the exhibition and navigate between its many venues and artistic projects.

WHERE CAN YOU READ AND LEARN MORE ABOUT DOCUMENTA FIFTEEN?

The collectives and artists participating in documenta fifteen are all present in the five routes you find in the illustrated stories of this book. So that you can go more into depth with the proposals and biographies of each collective and artist, we invite you to check out the other guide: the Handbook. This graphic companion is both independent of and complementary to that handbook.

This is a book for dreaming collectively!

Lumbunging Process

Daniella Fitria Praptono, 2020

SUGGESTED ITINERARIES

LOCAL ANCHOR TOUR

Duration of tour: approx. 2 hrs
(on foot and 15 mins by tram)
Distance: 5.5 km

The publishing house Rotopol, which is based in Kassel, sets out its own personal knowledge and experience of the city. Illustrators like Julia Kluge, Nadine Redlich, and Malwine Stauss offer a tour on which we can discover the creative processes and experiences inspired by some of the artistic projects involved in documenta fifteen and so respond to them in a collective and fun way.

WE ARE INVITED TO: draw, play, write, and even, if the exhibition space allows, dance and jump around!

PAGE 12

HUMOR TOUR
GET WITH IT! THERE IS A WHOLE LOT OF ACTION GOING ON

Duration of tour: approx. 1 hr 15 mins (on foot)
Distance: 5.7 km

Humor is a space for experimenting with new ideas; this is what the unique characters show us in the documenta fifteen filled with surprises and discoveries offered by Isabel Minhós Martíns and Bernardo P. Carvalho.

WE ARE INVITED TO: first to read to stimulate our thoughts and discover the route we will take later, at the end of the story. To walk the path that we have mentally committed ourselves to.

PAGE 28

INDEPEN﹏DENCE TOUR

Duration and distance: It's up to you!

A heroic character encourages us to choose our own adventure in this documenta fifteen full of animals, shapes, and fantastic characters offered by Jules Inés Mamone (Femimutancia)

WE ARE INVITED TO: dream and immerse ourselves in a parallel, independent experience where the borders between species, genders, and races are demolished.

PAGE 44

GENEROSITY TOUR
THE BEETLE'S JOURNEY

Duration of tour: approx. 1 hr 15 mins (on foot)
Distance: 6.4 km

lumbung can only flourish if each participant's way of thinking and making in the community is generous. That is what the little beetle in the tale by Verónica Gerber Bicecci does as she sets out on a documenta fifteen adventure with the sole idea of being able to tell stories and share everything she discovers with her community.

WE ARE INVITED TO: have the alert antennae and grounded gaze of an insect.

PAGE 60

TRANSPARENCY TOUR

Duration of tour: approx. 1 hr 25 mins
Distance: 5.3 km

Generating trust is the central to lumbung. Trust can't develop without a certain level of transparency. Innosanto Nagara unfolds a journey filled with questions we ask collectively about the community, the idea of transparency, and its possible meanings.

WE ARE INVITED TO: ask questions more than to look for answers.

PAGE 76

LOCAL ANCHOR TOUR

Duration: approx. 2hrs
(on foot and 15 mins by tram)
Distance: 5.5km

By Julia Kluge, Malwine Stauss
and Nadine Redlich with
Rotopol Publishing House

- **AR/GB** ATIS REZISTANS/ GHETTO BIENNALE
- **BAT** BRITTO ARTS TRUST
- **CM/CJ** CAO MINGHAO & CHEN JIANJUN
- **CD/AW** CENTRE D'ART WAZA
- **DP** DAN PERJOVSCHI
- **FPP** FEHRAS PUBLISHING PRACTICES
- **JAF** JATIWANGI ART FACTORY
- **MA** MARWA ARSANIOS
- **NTT** NGUYEN THRIN THI
- **PÖ** PINAR ÖGRENCI
- **SP** SOURABH PHADKE
- **TP** TARING PADI
- **TNC** THE NEST COLLECTIVE
- **TH** TRAMPOLINE HOUSE

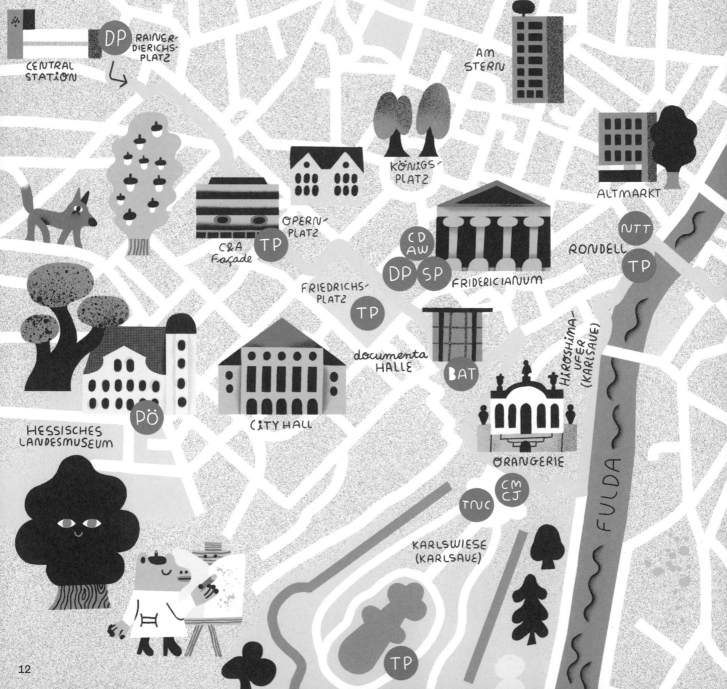

Collective work is very often constructed around the needs and practices of a specific locality and involves constant collaboration with a variety of people and communities in that locality.

The publishing house Rotopol, sets out its own universe for us and, in addition, with their knowledge, they give us an understanding of the city of Kassel. With lots of colorful illustrations and curious characters, you can discover your own surroundings. Local Anchor also means thinking about the possibilities and difficulties on site. Where does our food come from? What grows in our gardens and where does our trash actually go? Some artists at documenta fifteen are also raising these questions.

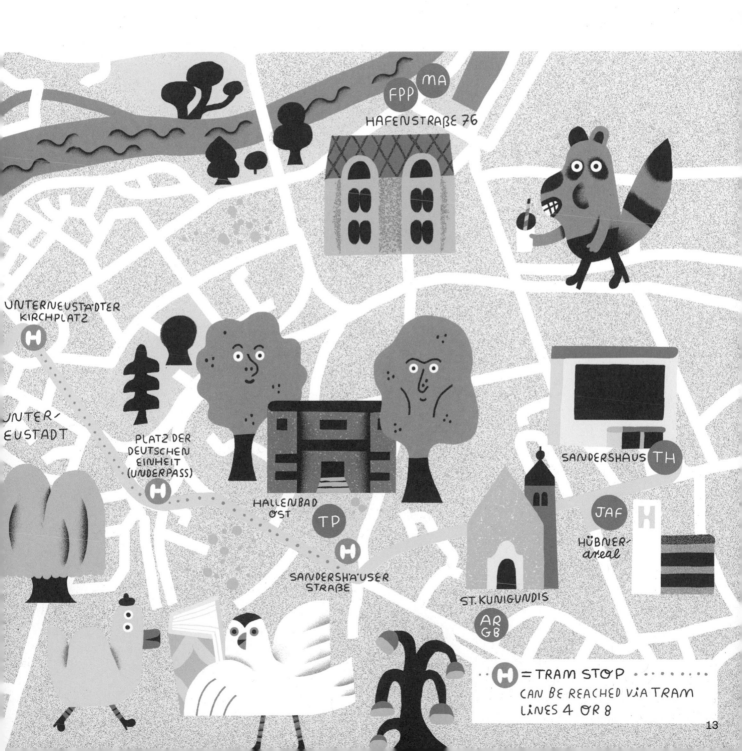

Hi!

WE ARE IN KASSEL, A FULL OF 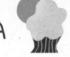 AND SURROUNDED BY 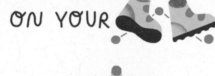. THE BROTHERS GRIMM THEIR FAIRY TALES HERE, AND KASSEL IS FAMOUS FOR BEING THE THIS ALSO HAS MANY THAT YOU CAN USE FOR AND TO IN THIS . PERHAPS YOU WILL EVEN SEE A BEHIND A ON YOUR

HELLO, WE ARE

WE ARRIVED HERE WITH

AND IN THE SKY ABOVE KASSEL TODAY WE SEE

WE ARE ESPECIALLY LOOKING FORWARD TO

We are a bridge!

On this tour you will move from place to place and walk through very distinctive parts of the city on many different paths. Let your movements be influenced by your surroundings. Find inspiration in the patterns of the cobblestones, the corners and curves of stairs and bannisters, the lines and shapes of buildings, trees and streetlamps ...

I am stairs!

I am flat!

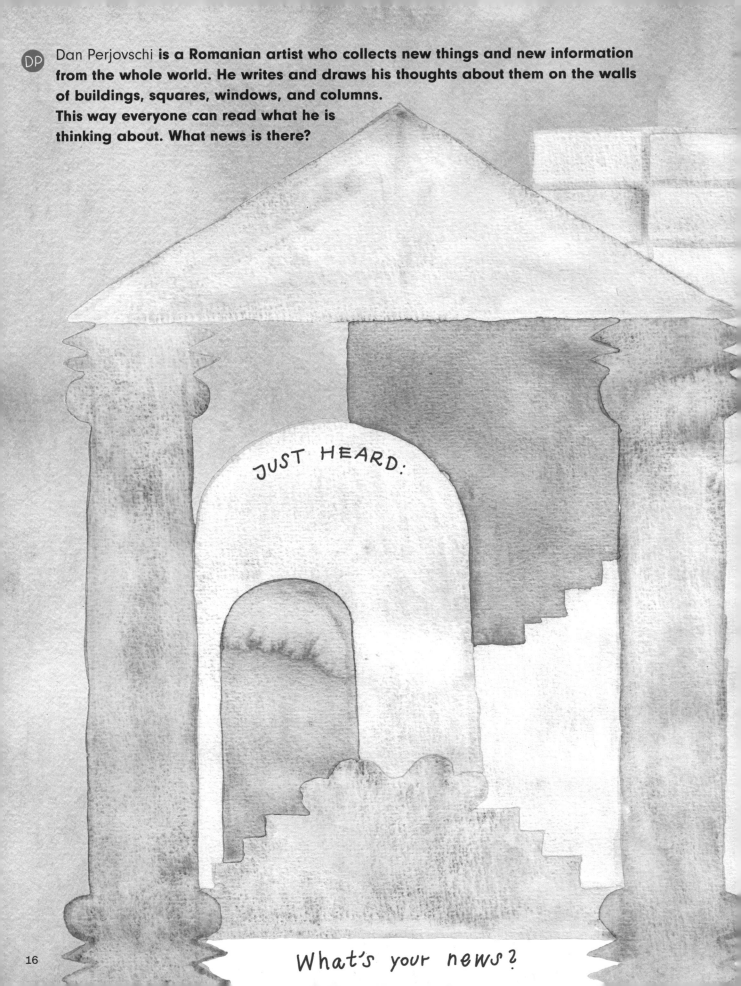

Dan Perjovschi **is a Romanian artist who collects new things and new information from the whole world. He writes and draws his thoughts about them on the walls of buildings, squares, windows, and columns. This way everyone can read what he is thinking about. What news is there?**

IN THE CENTER OF THE CITY,
MANY LETTERS ARE ROMPING ABOUT.
THEY BALANCE ON THE HOUSES,
DANCE ACROSS THE SIGNS,
AND STICK TO SHOP WINDOWS.
WHICH ONES CAN YOU CAPTURE
WITH YOUR PENCIL?

Take a moment and look around you. Where are you located? And what do your surroundings look like?

What is close?

You are here.

Where are you standing?

What is far away?

Taring Padi **is a collective of artists and activists. In street protests and unusual actions, they are striving for social improvements in Indonesia with their art. They carry these large figures around with them, which they make from cardboard and paint. Who are these figures? What do they look like? How are they dressed?**

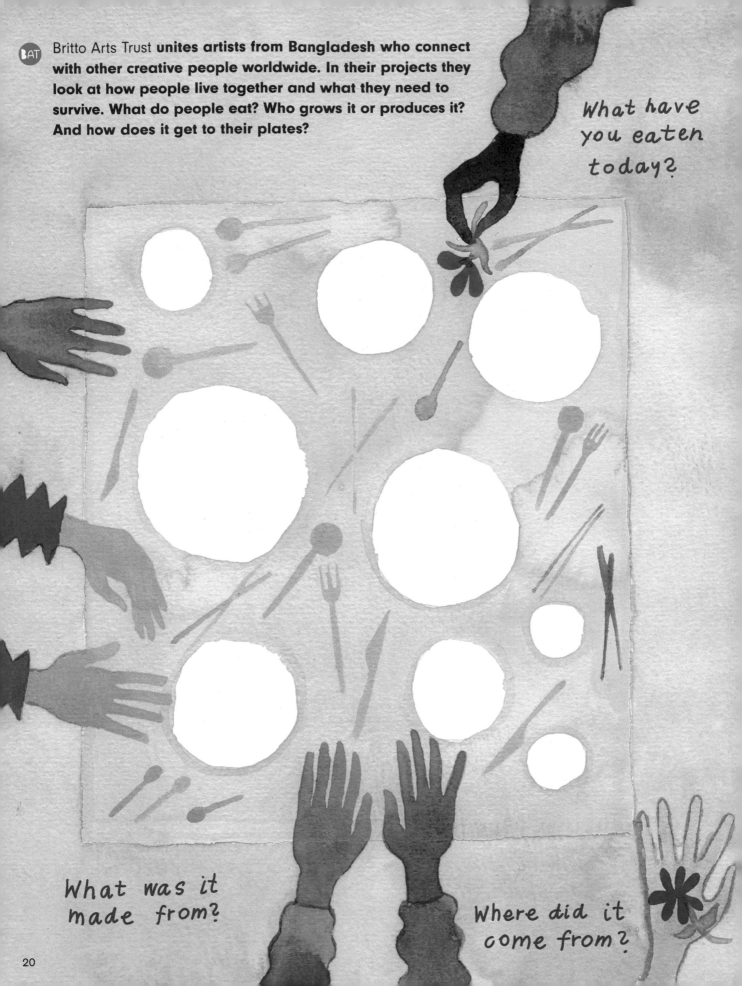

Britto Arts Trust **unites artists from Bangladesh who connect with other creative people worldwide. In their projects they look at how people live together and what they need to survive. What do people eat? Who grows it or produces it? And how does it get to their plates?**

What have you eaten today?

What was it made from?

Where did it come from?

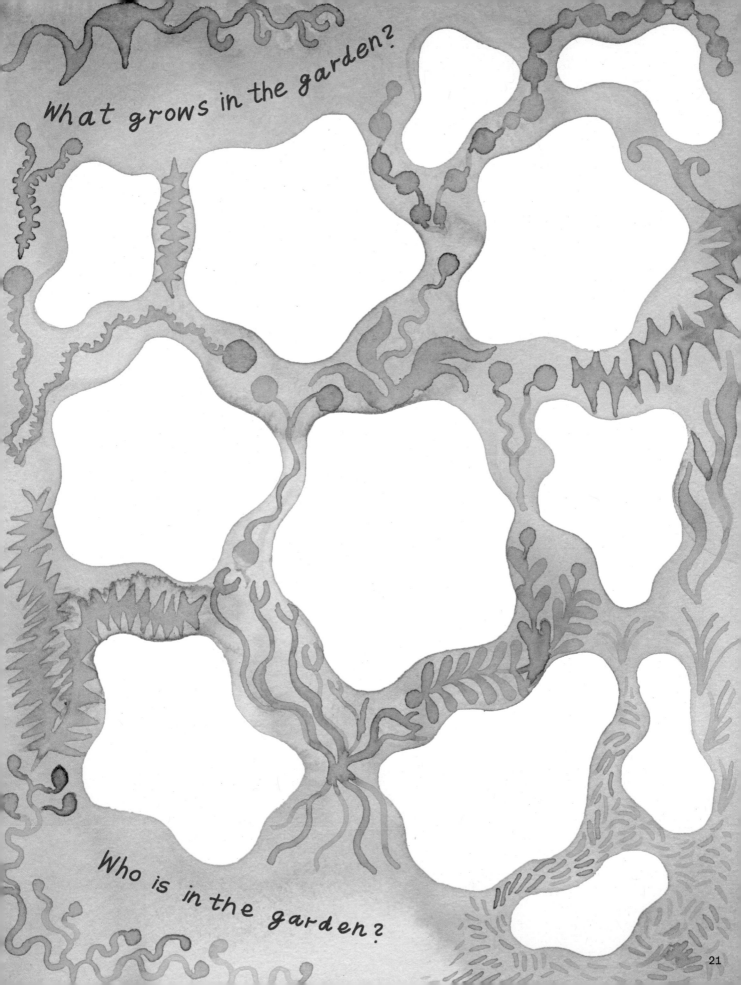

What grows in the garden?

Who is in the garden?

21

The Nest Collective **is a group of artists from Kenya. In their art, they grapple with how our world functions today and what connections there are between everyday life in different countries. When things are no longer used, or when they are broken and replaced by new ones, they often end up in the trash. But where does all the trash go?**

IMAGINE A PIECE OF TRASH SUDDENLY COMING TO LIFE!

DRAW A COMIC!

WHAT IS ITS TITLE?

WHO IS YOUR MAIN CHARACTER?

WHAT WILL HAPPEN?

WHAT SMELLS SO FUNNY HERE?

OOH! SOMEONE ALMOST STEPPED ON ME!

YOU WON'T BELIEVE EVERYTHING I'VE ALREADY SEEN HERE!

MHM?!

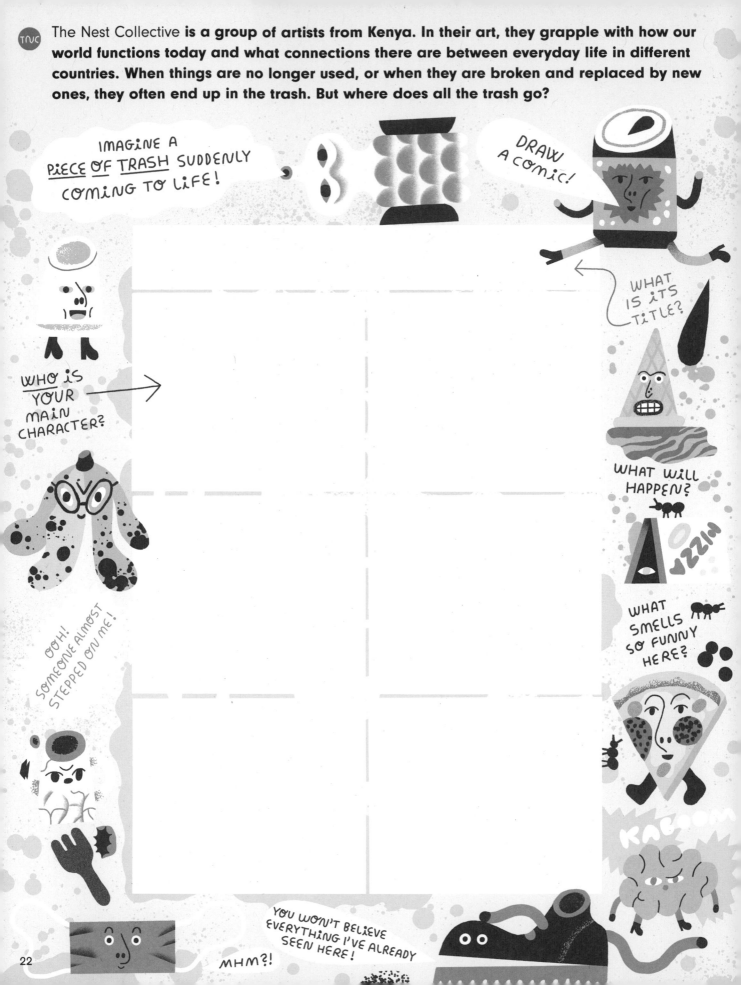

NTT Nguyen Trinh Thi **is an artist from Vietnam. In her art she often works with sounds and combines memories, landscapes, and stories in her sound pictures. She explores how the invisible can be made visible through the experience of hearing. How do sounds affect people? What stories do noises tell?**

What are you hearing right now?

What could the noises look like?

Taring Padi **is a group of art students and activists from Indonesia who have been drawing attention to injustices for more than twenty years. The artists question politics, inform people, and engage with their art for a better future. They write their demands on large banners and signs with which they express their opinion at protests and carnivals. What changes should they ask for to make the world more fair?**

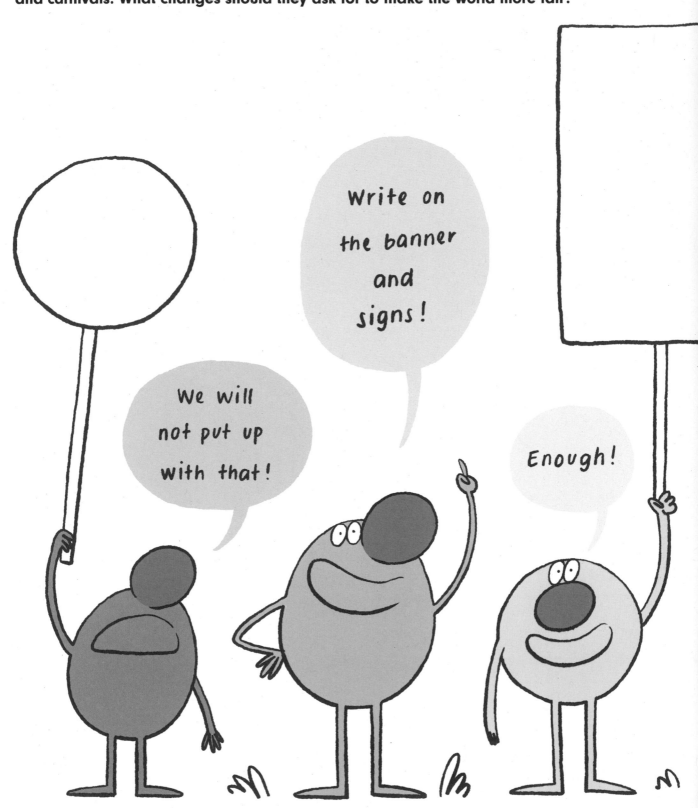

 Jatiwangi art Factory **is a cooperative project of Indonesian artists. Their work deals among other things with how building materials can be made from earth. In the city of Jatiwangi, the residents have a close connection to the clay in the earth from which bricks are made. What can you build with clay bricks? What can you create using earth?**

What plants are growing here?

What patterns do you find?

What kind of stones are here?

Trampoline House **is a group of artists, asylum seekers, and activists in Denmark who support the rights of people who had to leave their homes and are seeking refuge. Together they are creating a home for people from different backgrounds. What could such a place look like?**

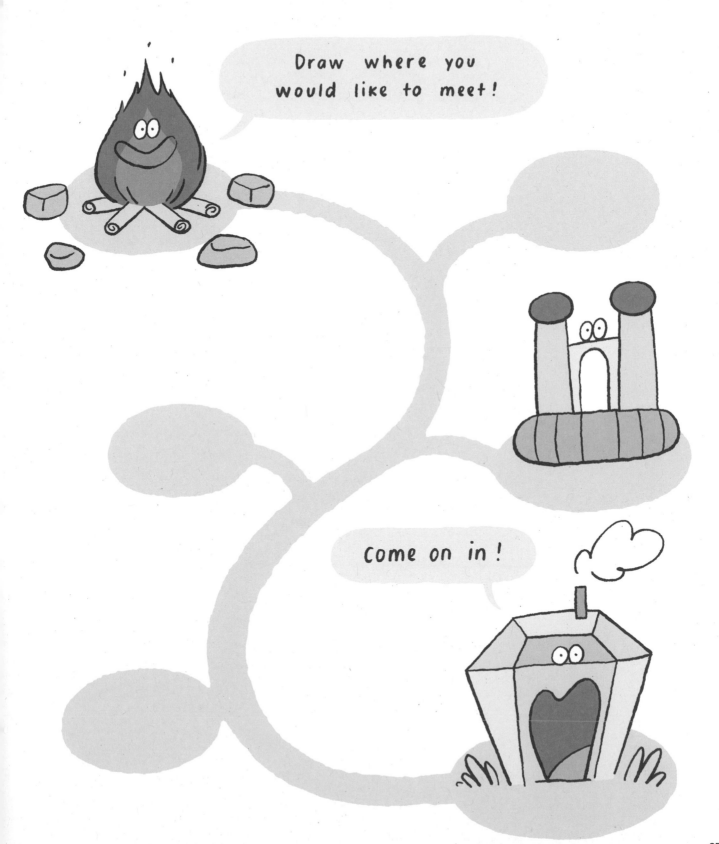

By Isabel Minhós Martins
and Bernardo P. Carvalho

Duration: approx. 1 hr 15 mins
Distance: 5.7 km

GET WITH IT!
There is a whole lot of action going on

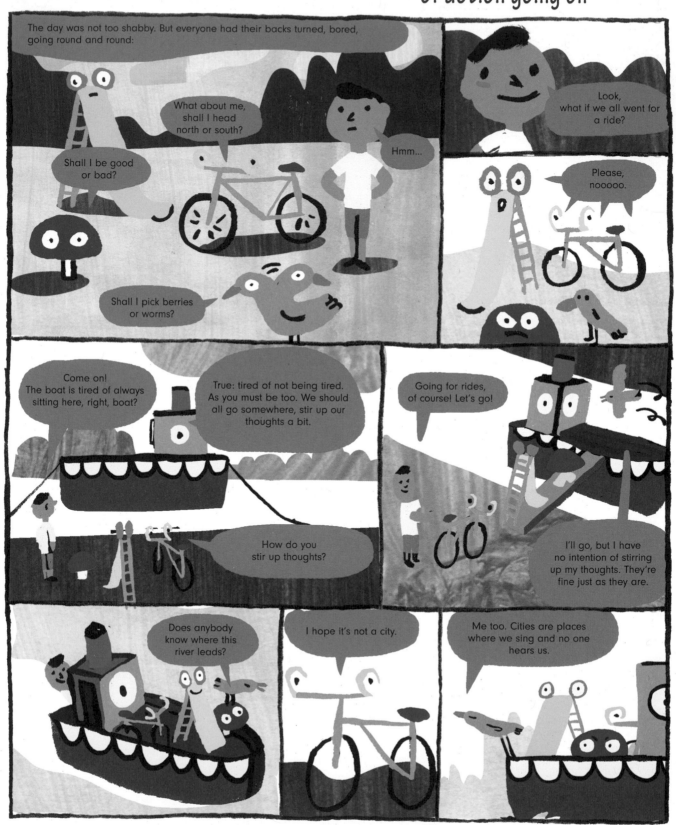

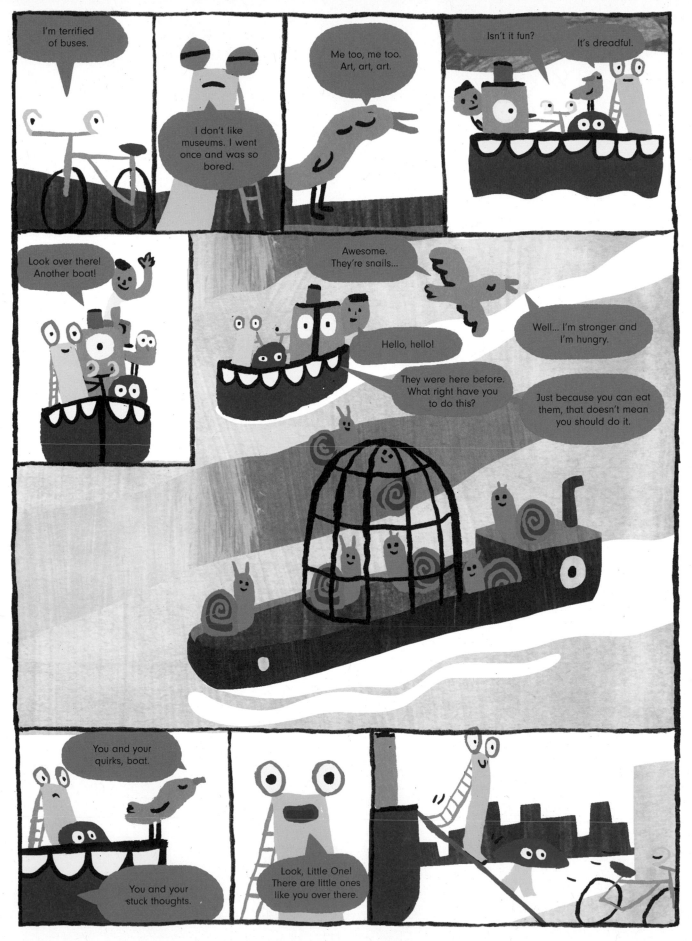

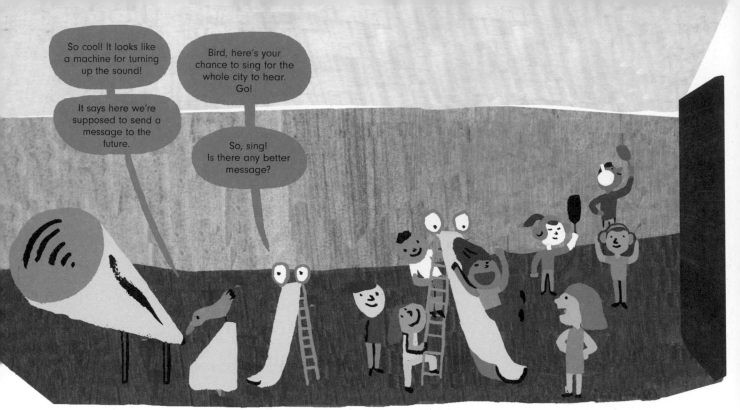

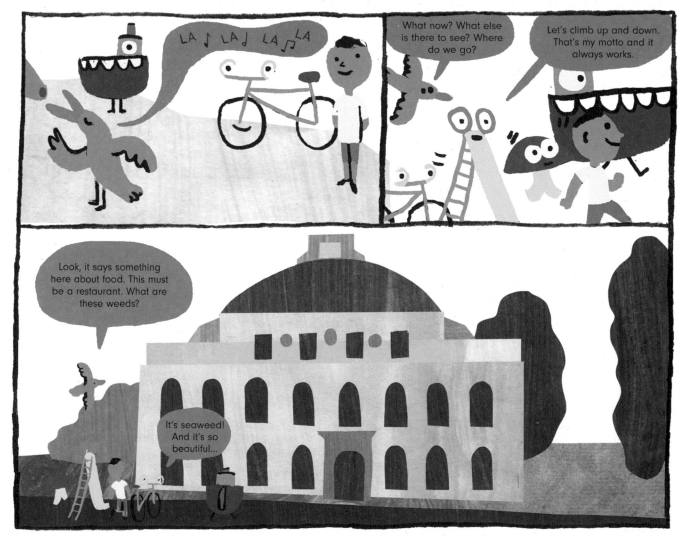

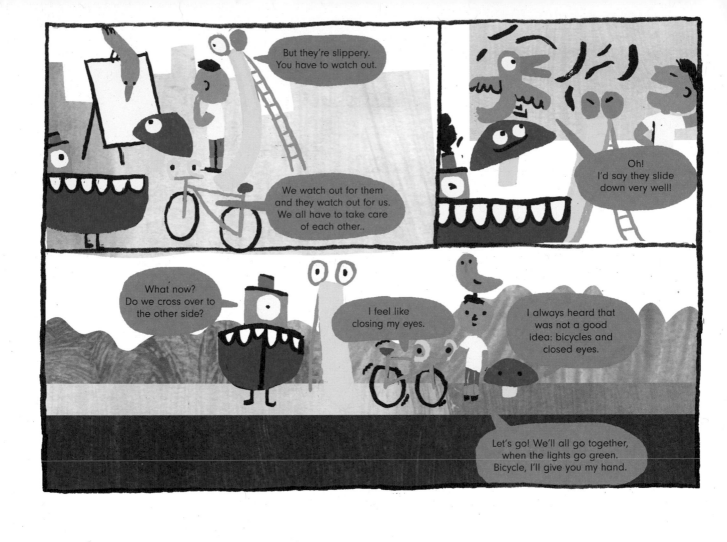

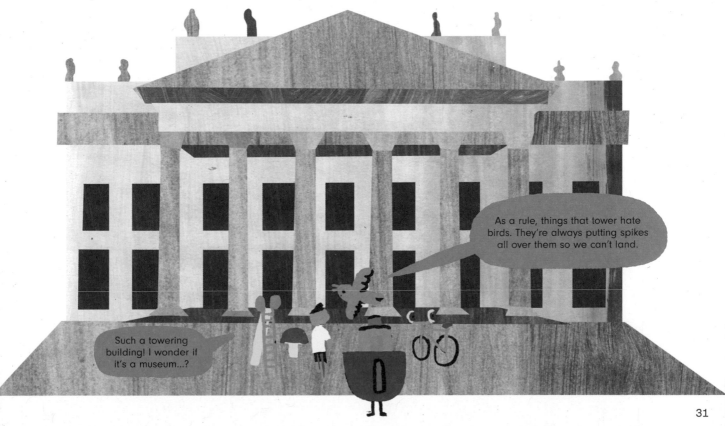

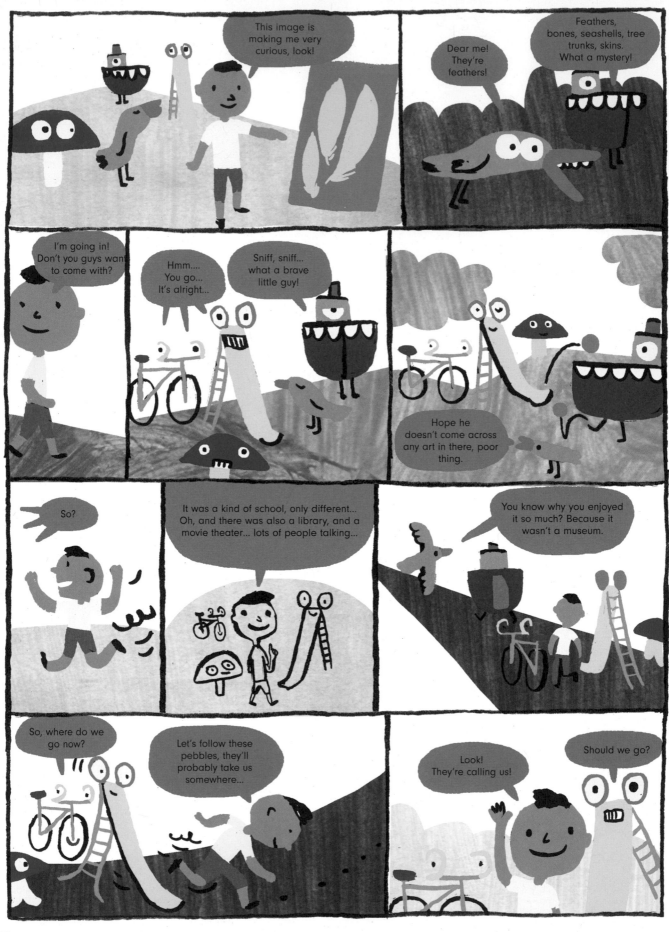

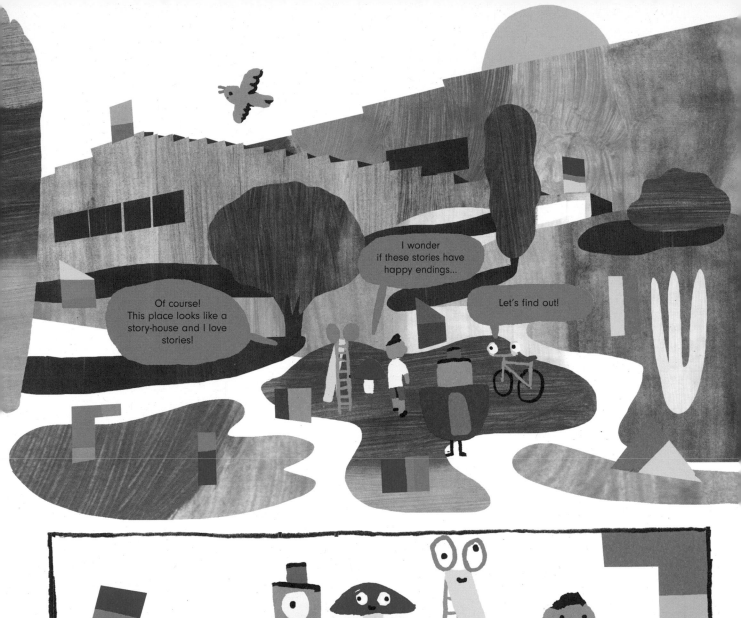

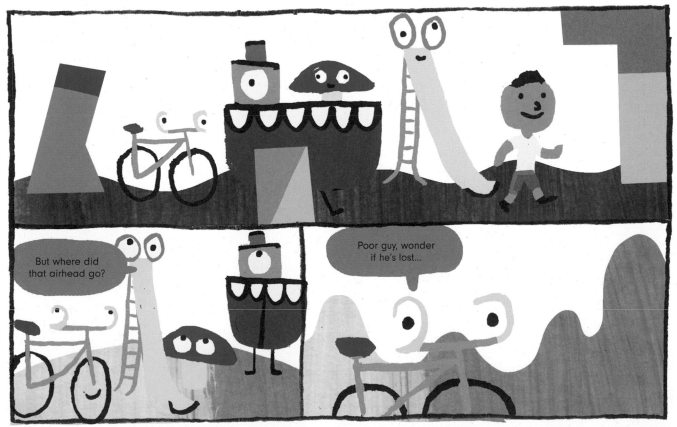

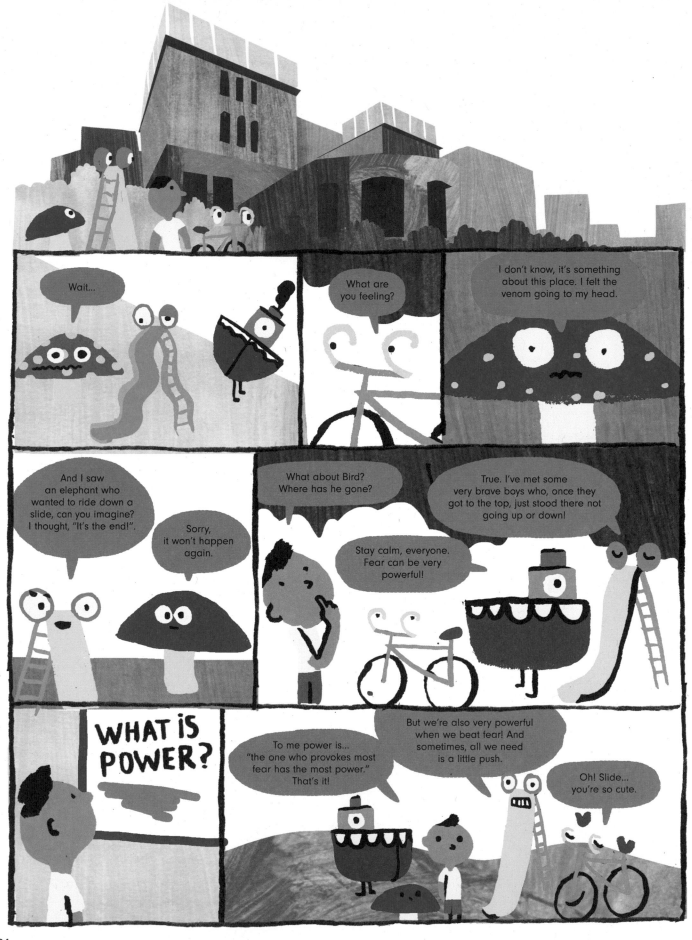

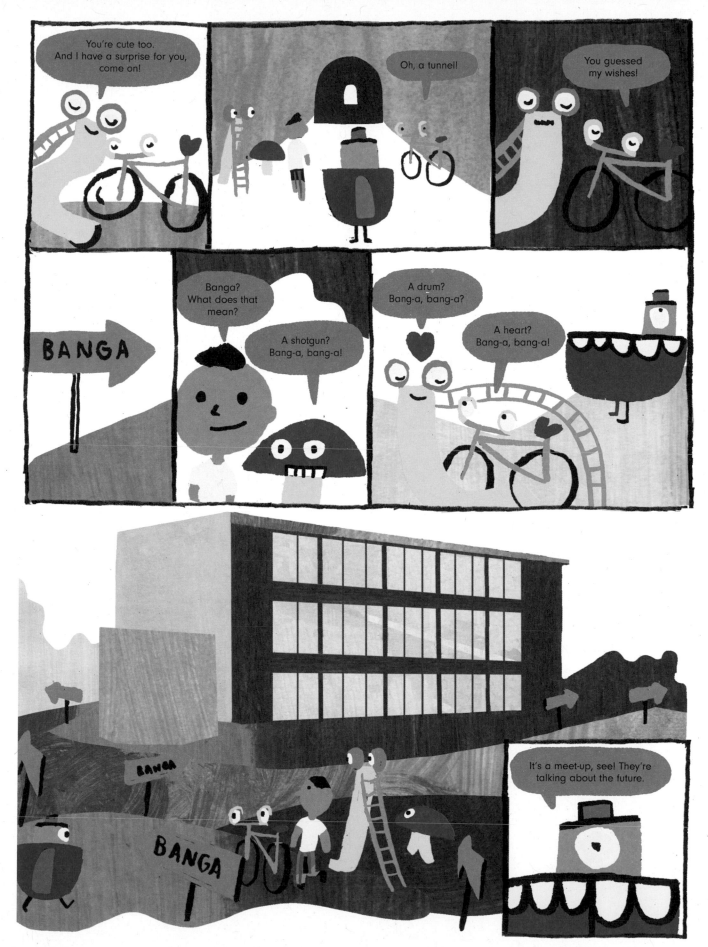

35

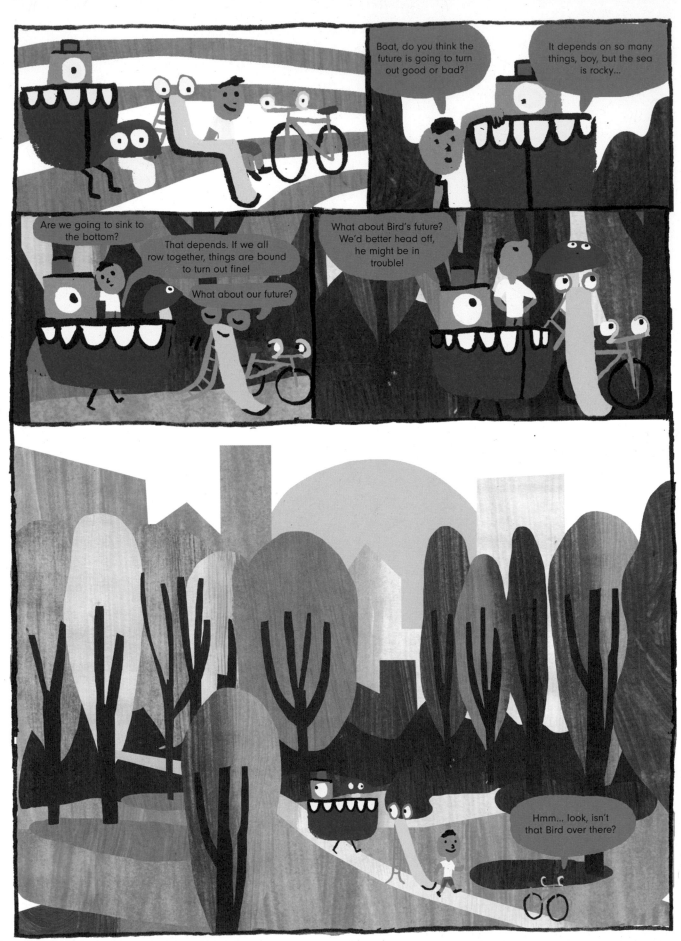

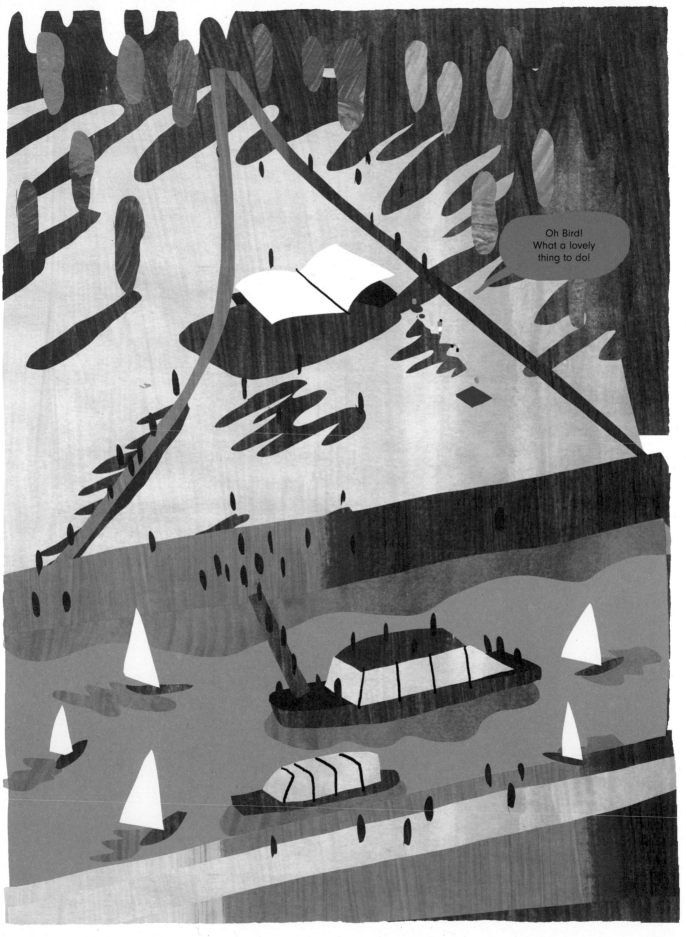

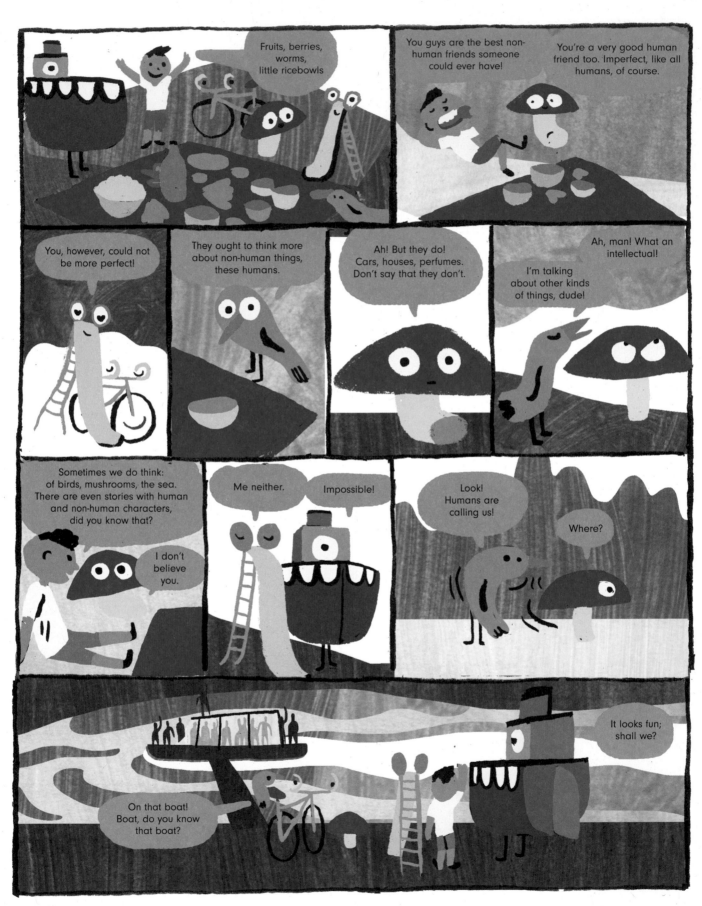

38

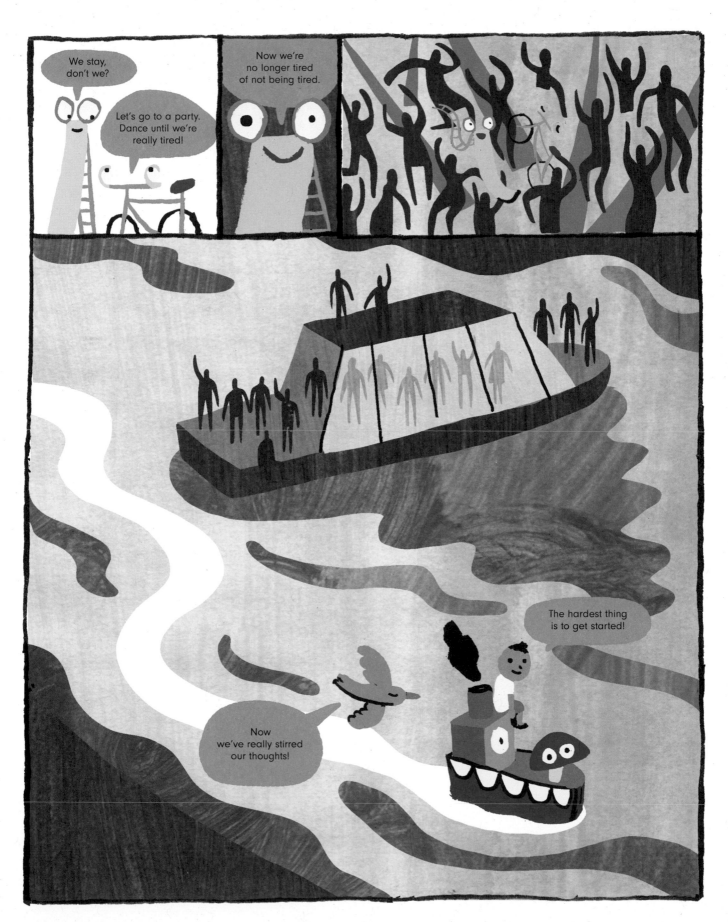

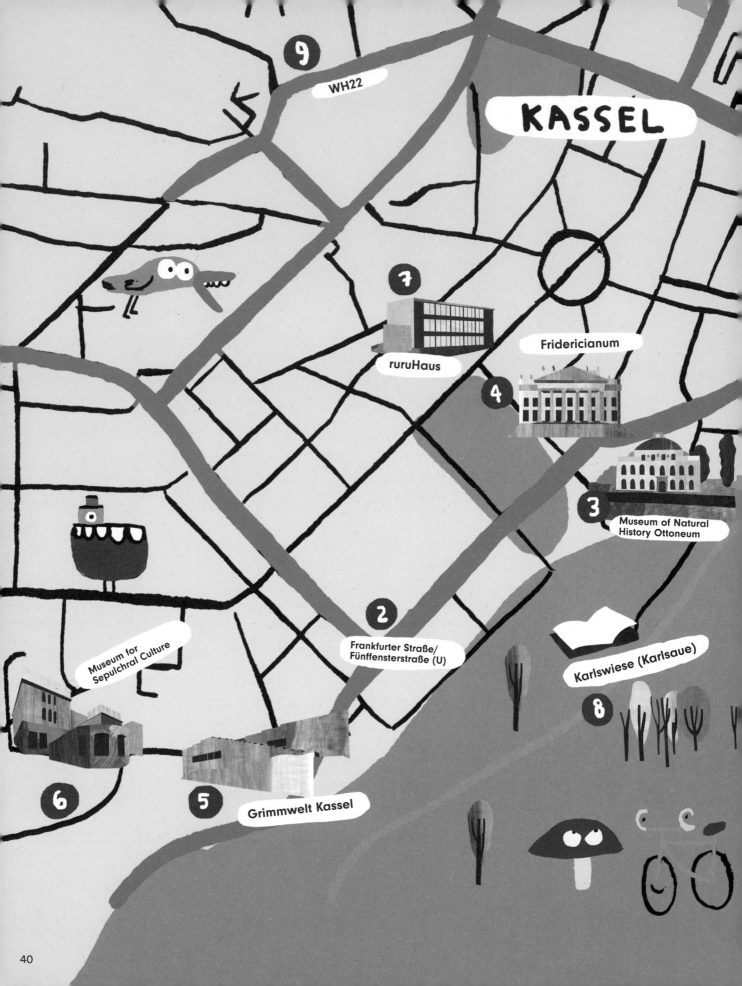

KASSEL

WH22

ruruHaus

Fridericianum

Museum of Natural
History Ottoneum

Museum for
Sepulchral Culture

Frankfurter Straße/
Fünffensterstraße (U)

Karlswiese (Karlsaue)

Grimmwelt Kassel

40

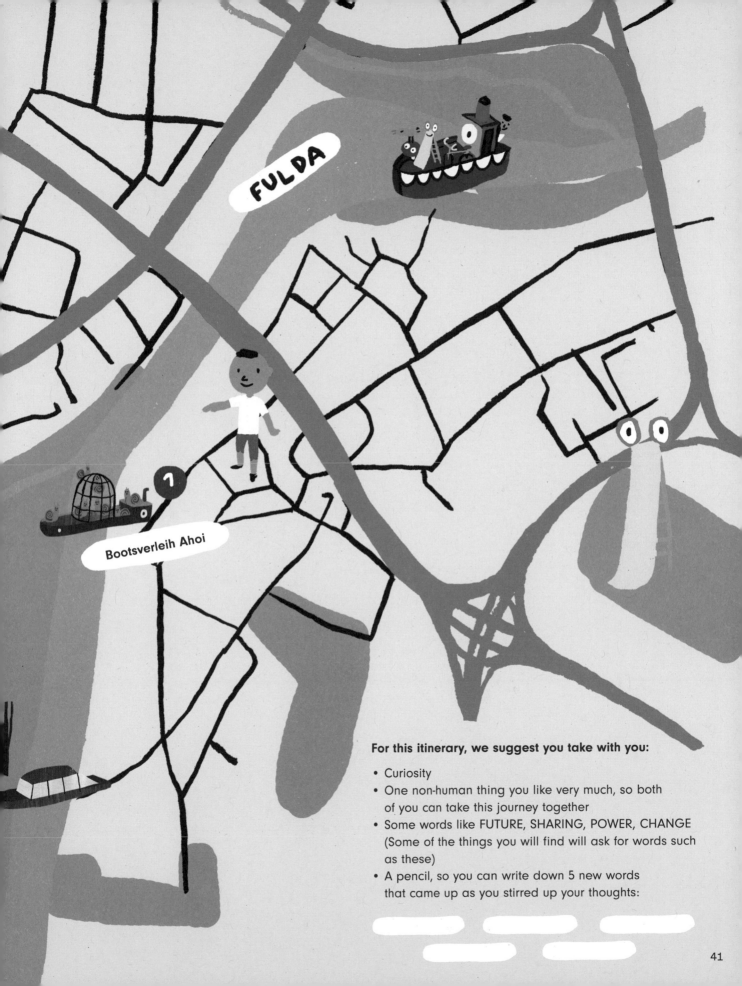

FULDA

Bootsverleih Ahoi

For this itinerary, we suggest you take with you:

- Curiosity
- One non-human thing you like very much, so both of you can take this journey together
- Some words like FUTURE, SHARING, POWER, CHANGE (Some of the things you will find will ask for words such as these)
- A pencil, so you can write down 5 new words that came up as you stirred up your thoughts:

If you want to spend a day stirring up your thoughts like boat, slide, bird, mushroom and the little one, all you have to do is follow our itinerary. Bird couldn't even tell, but he passed by some museums and saw projects by many artists: all things that made him stir up his thoughts. (And it wasn't so bad after all...)

THESE ARE THE ACTUAL PLACES OUR LITTLE GROUP PASSED THROUGH:

1 Bootsverleih Ahoi

The boat with the snails our friends saw on the Fulda river was created by artist Chang En-Man, from Taiwan. She likes to do research on who is boss in certain places: those who were already there? Those who are the strongest?

2 Frankfurter Straße / Fünffensterstraße (Underpass)

In the underpass, there is a sound installation by two artists who go by the name Black Quantum Futurism. These artists work together and think about things like time, Africa, the future.

3 Museum of Natural History Ottoneum

Bird and friends were very intrigued by a video showing seaweed (the one bird tried to eat, remember?). Well, wouldn't you know?, it was an installation by an artist collective called ikkibawiKrrr (now try saying that name out loud!).

4 Fridericianum

The building Bird thought was so towering was a museum, of course! And inside, there was art...
In the museum you will also find Keleketla! Library (from South Africa) and a film cycle organized by Komîna Fîlm a Rojava (a film-making collective).

5 Grimmwelt Kassel

This is an exhibition house dedicated to the Brothers Grimm. Here, while Bird went missing, our friends stumbled upon objects by two artists: Jumana Emil Abboud, from Palestine, and Agus Nur Amal PMTOH, from Indonesia.

6 Museum for Sepulchral Culture

In this museum, our friends felt some chills up their spines. But later on, they got to thinking about the power of fear and other powers. Artist Erick Béltran did the same by transforming into art the result of an investigation he conducted around the question – "What is power?"

7 ruruHaus

Here, everybody learned a new word: Bangas (meetups!). When we get together for a chat sometimes we find ourselves thinking about the future: what can we do so it will turn out alright? A collective called Arts Collaboratory believes that, if we stand united, everything can be made easier.

8 Karlswiese (Karlsaue)

At the city park, Bird surprised his friends with a generous picnic. And then they all got to talking about things in the world, both human and non-human, inspired by the La Intermundial Holobiente collective. When it was already time to get back, they caught sight of the boat from ZK/U – Center for Art and Urbanistics .

9 WH22

Of course Slide and Bicycle had to go out and celebrate all that love. And they chose, of course, a party organized by Party Office b2b Fadescha. (It was spectacular and they only got home at break of dawn!)

GET WITH IT!
There is a whole lot of action going on

We're not always tired because we've worked too much, thought too much or had too much fun. The reason might well be the opposite: we feel tired because we've been lying still too long and need some exercise. Outside and inside. Arms, legs or belly, but also ideas, thoughts, experiences. There are times in our lives when tiredness springs from there (has it ever happened to you?).

The characters in our story were feeling like this: tired of not being tired, poor guys. However, it was this tiredness, this kind of laziness mixed with impatience, which acted as a spark that made them change. Determined to go for a ride in order to "stir up their thoughts", they came across a few surprises along the way (museums, parks, art projects, the horror!) that made them feel more connected, more awake.

Helping each other out, talking to each other, sharing what they felt, they observed unusual things and thought about things that were even more unusual! They had a day they won't ever forget.

Of course, they didn't even suspect many of the things they saw were museums and art projects; but does it make any difference what they were, anyway? What matters is what happened to them.

WHAT ABOUT YOU –
WHAT WILL HAPPEN TO YOU?

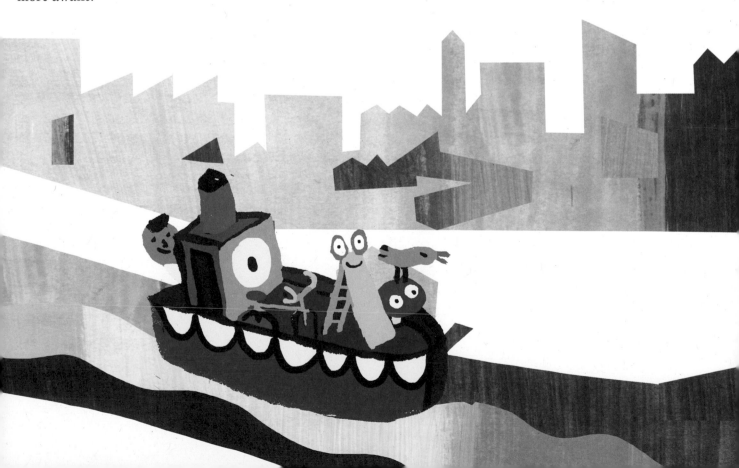

INDEPENDENCE TOUR

By Jules Inés Mamone
(Femimutancia)

Duration and Distance: It's up to you!

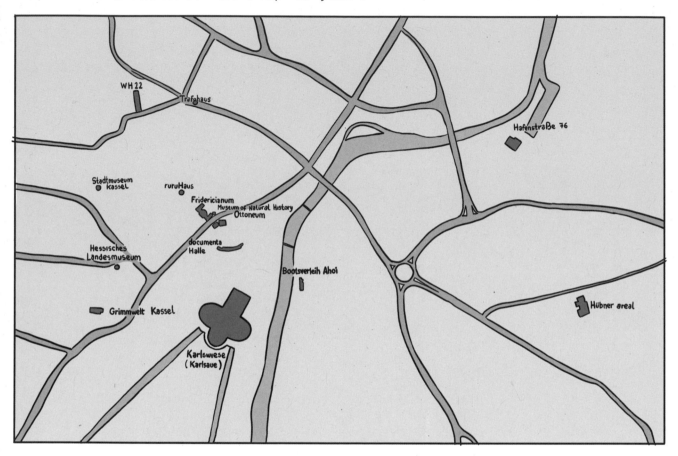

Another important lumbung value needed for communal action is independence—the ability to make decisions without being influenced by external agents or agendas. As we're aware that complete independence is difficult or even impossible, it's important to allow yourself to be guided by its spirit and tend toward interdependence. Here, an androgynous figure urges us to choose our own adventure in the documenta fifteen creation presented by Jules Inés Mamone (Femimutancia).

Hand in hand with this heroic character, we immerse ourselves in a unique world of incredible animals, figures, and places. We decide our own route to navigate, looking for resemblances, similarities with and differences from reality in order to construct a parallel, independent existence where the boundaries between races, genders, and species are blown away.

44

ALICE YARD. ANOTHER ROADMAP AFRICA CLUSTER (ARAC). ARCHIVES DES LUTTES DES FEMMES EN ALGÉRIE. BAAN NOORG COLLABORATIVE ARTS AND CULTURE. CHIMURENGA. CINEMA CARAVAN AND TAKASHI KURIBAYASHI. FAFSWAG. FONDATION FESTIVAL SUR LE NÍGER. GRAZIELA KUNSCH. INLAND. KIRI DALENA. OFF-BIENNALE BUDAPEST. OOK_. SADA [REGROUP]. THESE ARE THE:

INDEPENDENCE TOUR

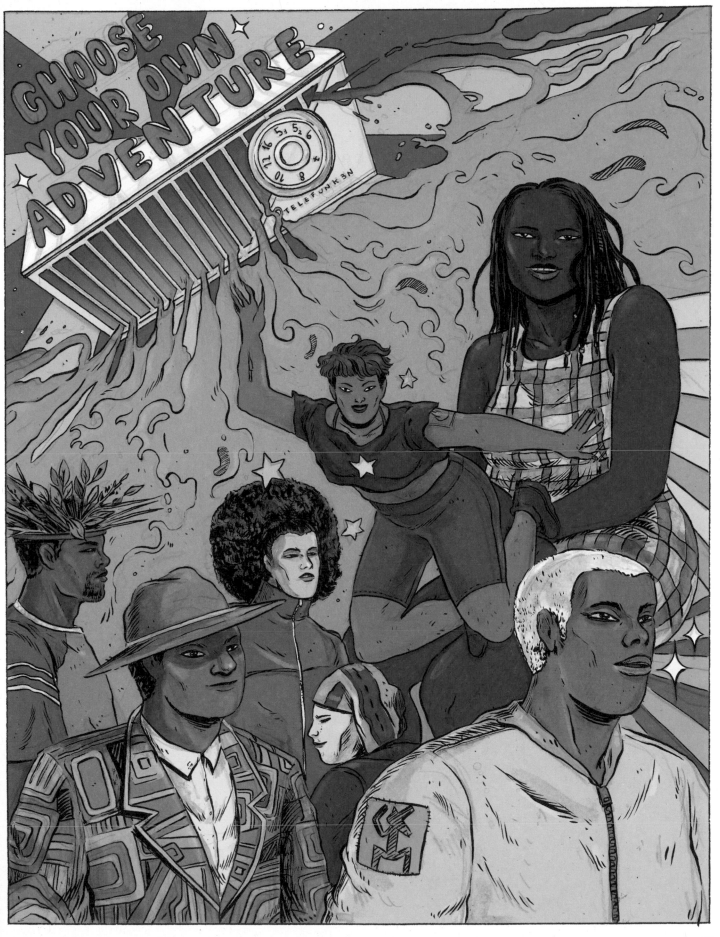

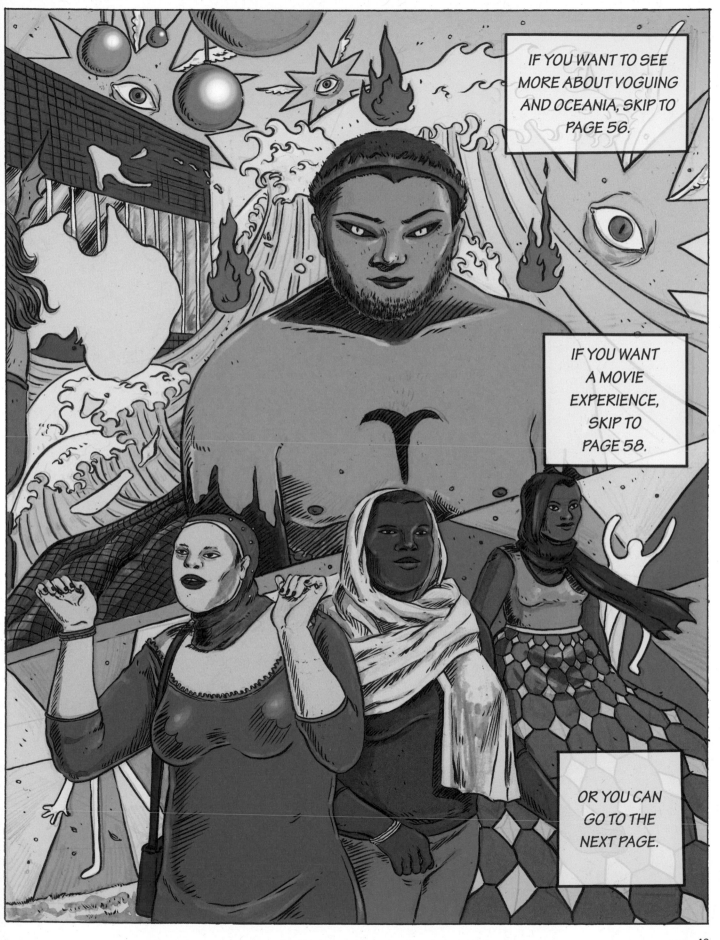

IF YOU WANT TO SEE MORE ABOUT VOGUING AND OCEANIA, SKIP TO PAGE 56.

IF YOU WANT A MOVIE EXPERIENCE, SKIP TO PAGE 58.

OR YOU CAN GO TO THE NEXT PAGE.

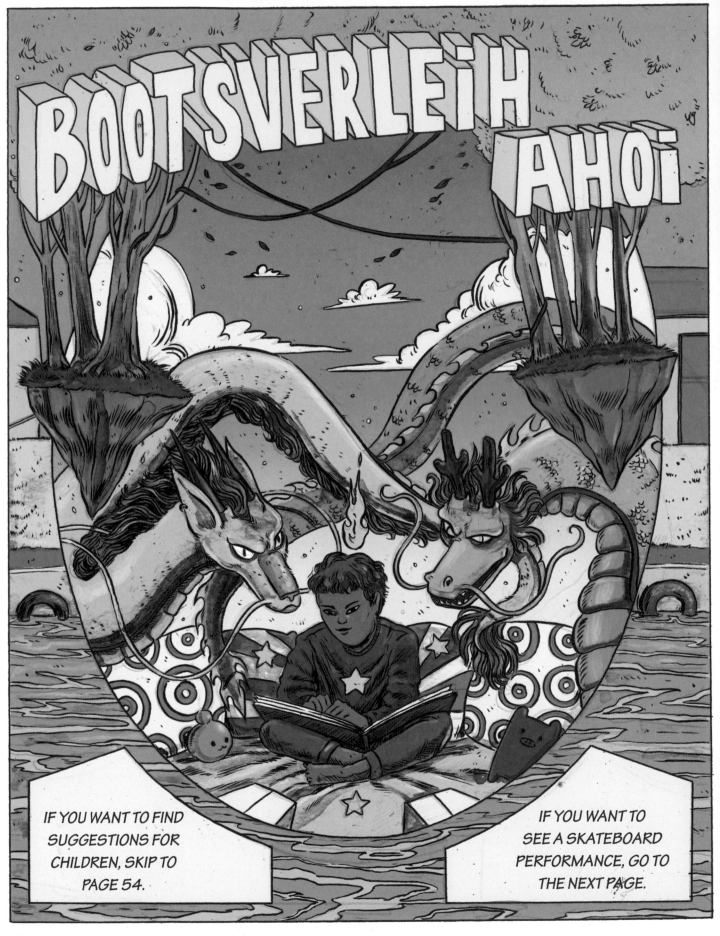

IF YOU WANT TO FIND SUGGESTIONS FOR CHILDREN, SKIP TO PAGE 54.

IF YOU WANT TO SEE A SKATEBOARD PERFORMANCE, GO TO THE NEXT PAGE.

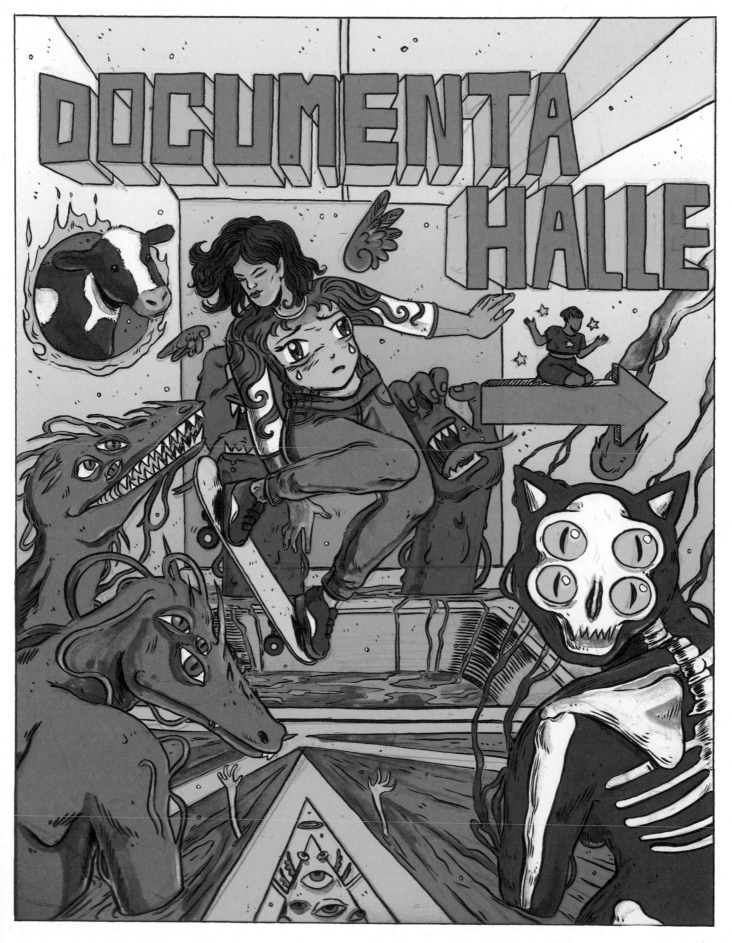

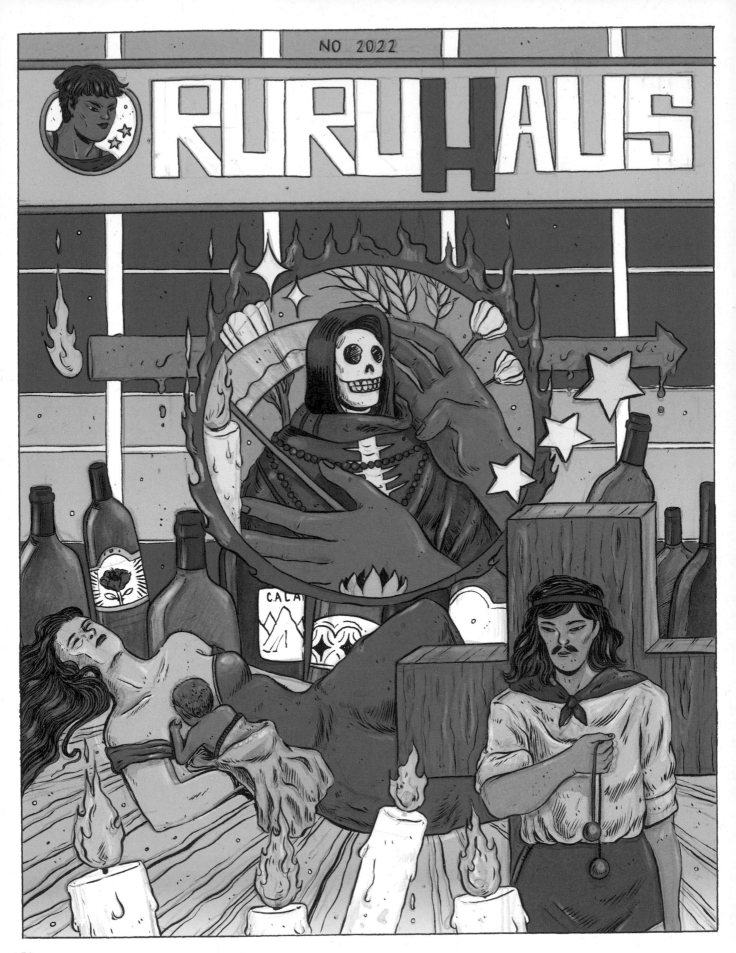

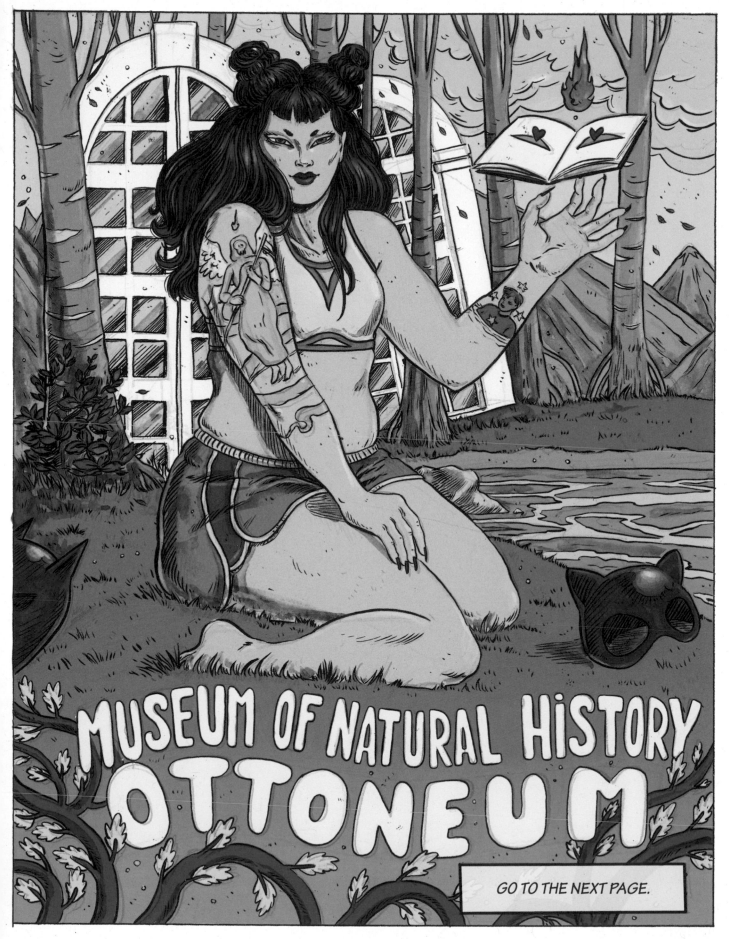

MUSEUM OF NATURAL HISTORY
OTTONEUM

GO TO THE NEXT PAGE.

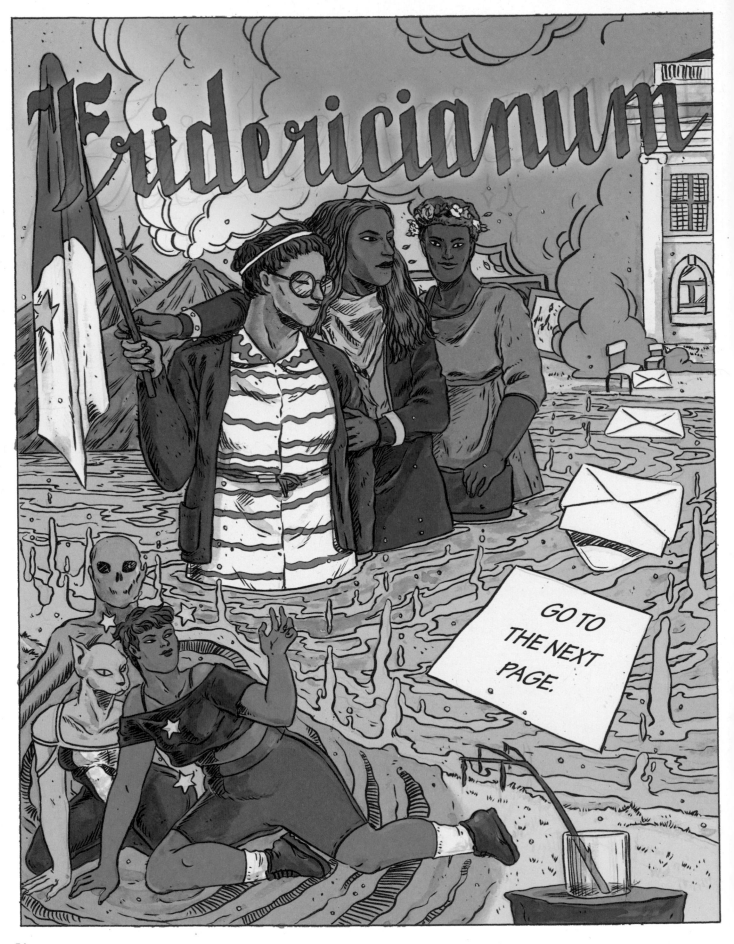

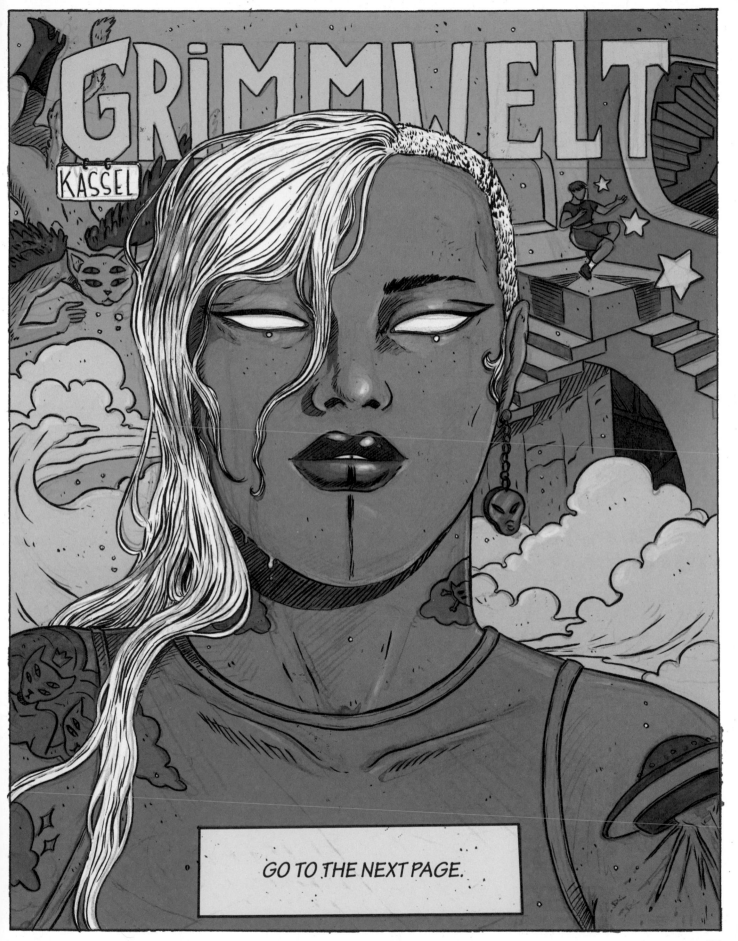

GO TO THE NEXT PAGE.

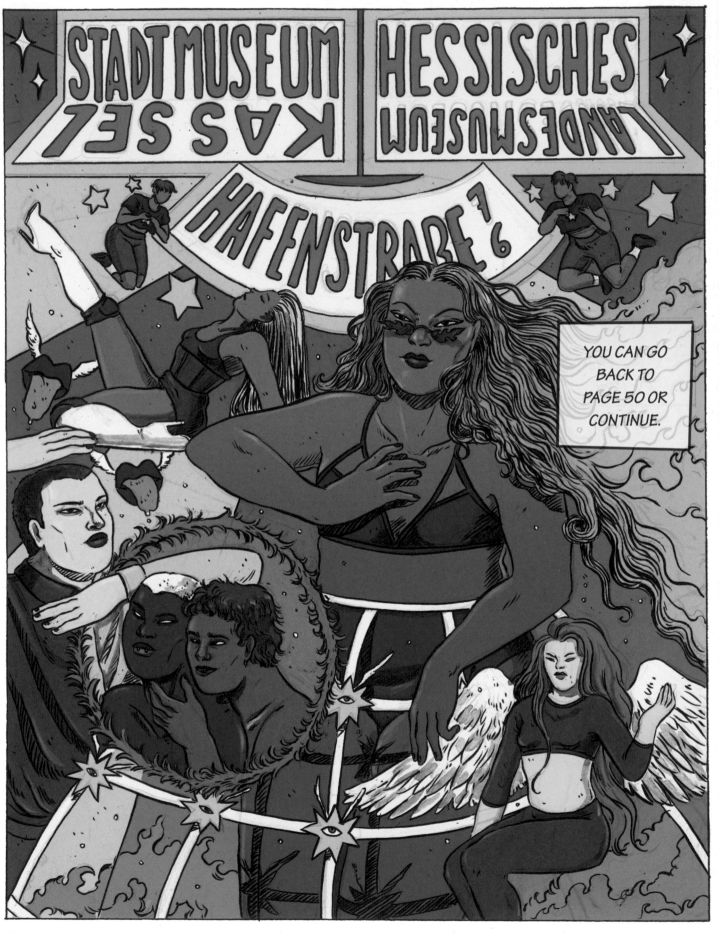

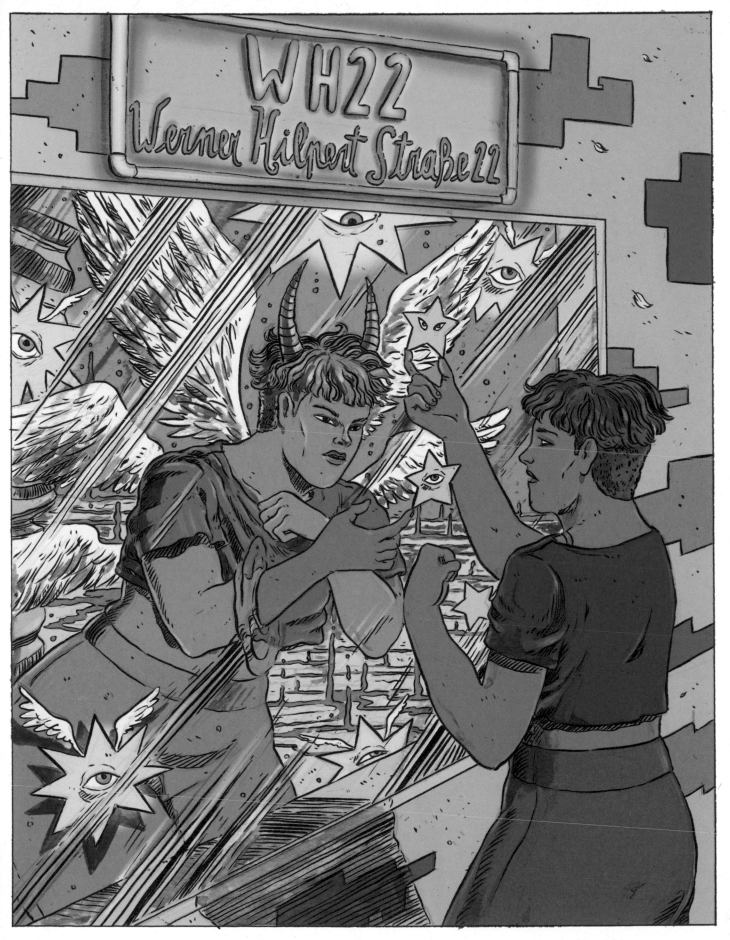

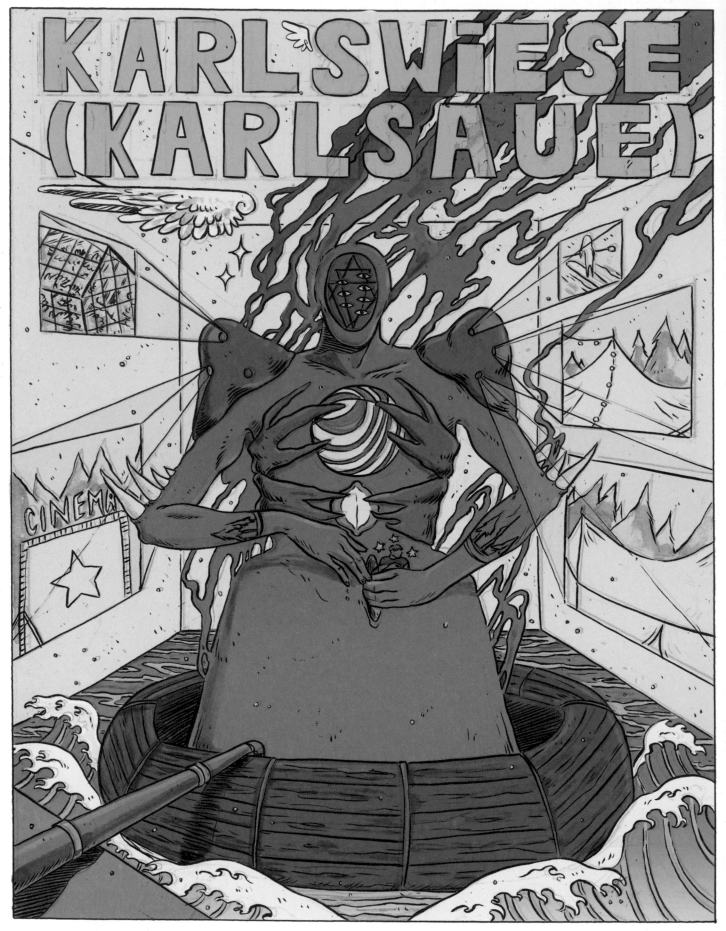

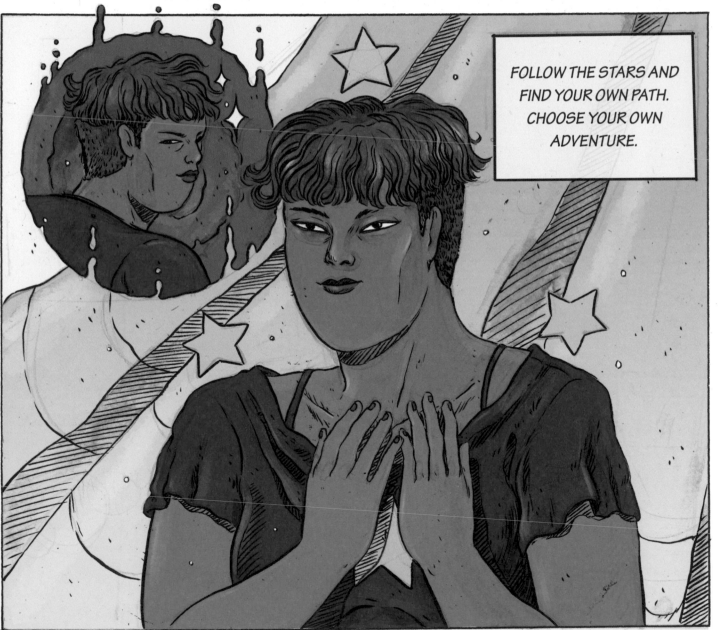

FOLLOW THE STARS AND FIND YOUR OWN PATH. CHOOSE YOUR OWN ADVENTURE.

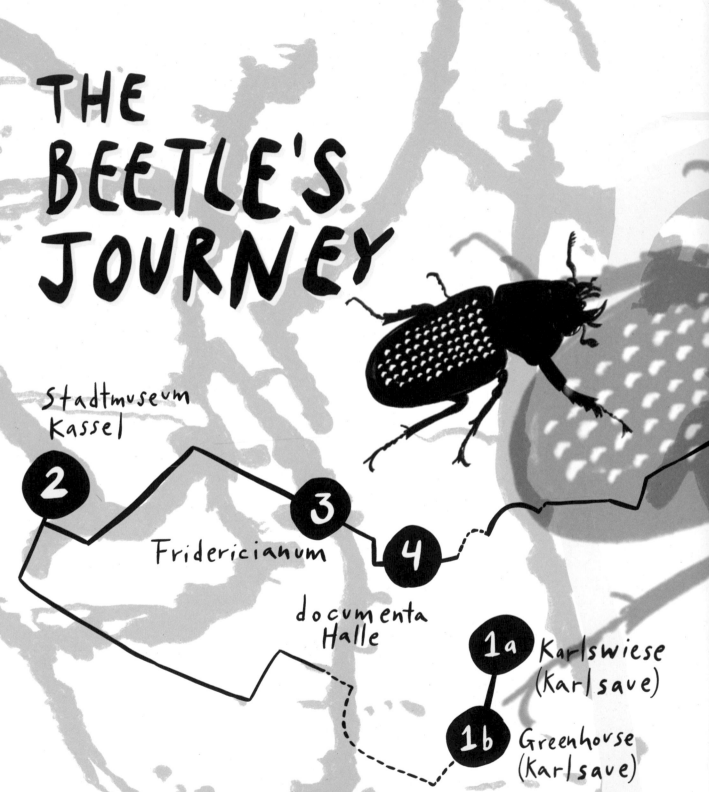

GEN*e*ROSITY TOUR

By Verónica
Gerber Bicecci

Duration: approx. 1 hr 15 mins
Distance: 6.4 km

THE BEETLE'S JOURNEY

Stadtmuseum
Kassel

2

Fridericianum

3

4

documenta
Halle

1a Karlswiese
(Karlsaue)

1b Greenhouse
(Karlsaue)

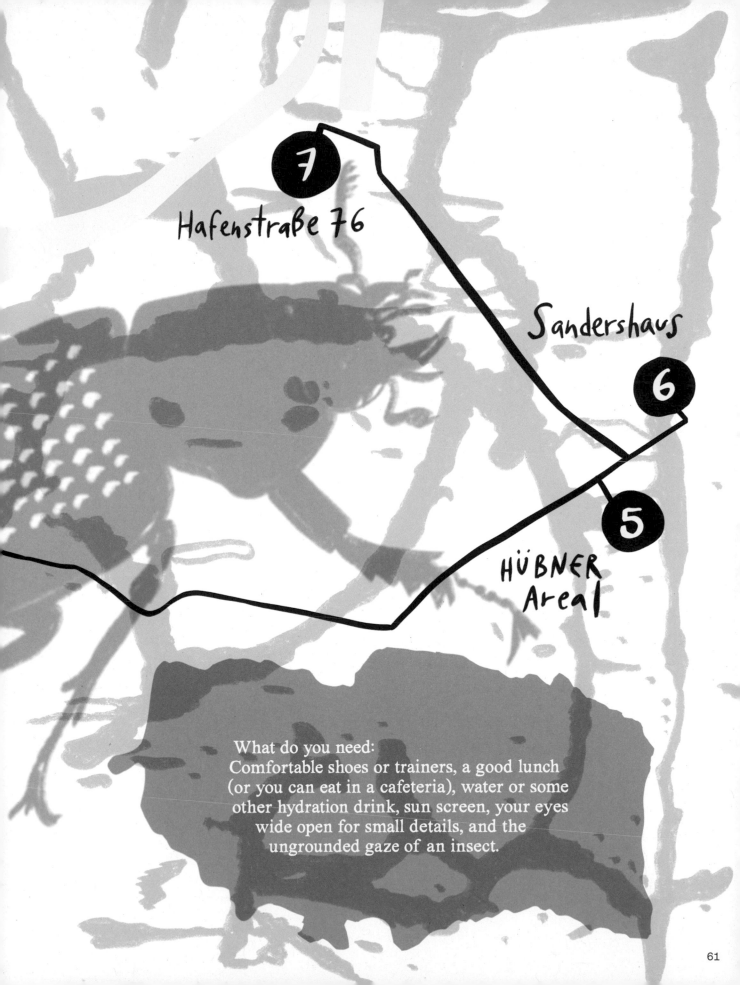

7

Hafenstraße 76

Sandershaus

6

5

HÜBNER
Areal

What do you need:
Comfortable shoes or trainers, a good lunch
(or you can eat in a cafeteria), water or some
other hydration drink, sun screen, your eyes
wide open for small details, and the
ungrounded gaze of an insect.

MÁS ARTE MÁS ACCIÓN

The beetle had started her life in the greenhouse in Karlsaue Park, but she was so small that when she tried to learn to write (as all beetles have to) she made such fine scratches on the tree bark that they were almost impossible to read. She thought she wasn't up to that task and so one day told her father, the beetle xylograph historian, that she wanted to leave the greenhouse to see what was outside. The problem was to find a way out because the humans kept everything tightly shut. Her mother, the carpenter beetle, suggested a plan that was complicated but by no means impossible. She gathered together all the adult beetles, the larvae, and pupae and asked them to push over a tall, slender tree trunk. After a while and a great deal of pushing, the trunk fell against the glass greenhouse wall under its own weight. A hole was made in the glass, so tiny that only a small beetle could fit in it. Without a second thought, the beetle entered the hole and was soon flying through the air.

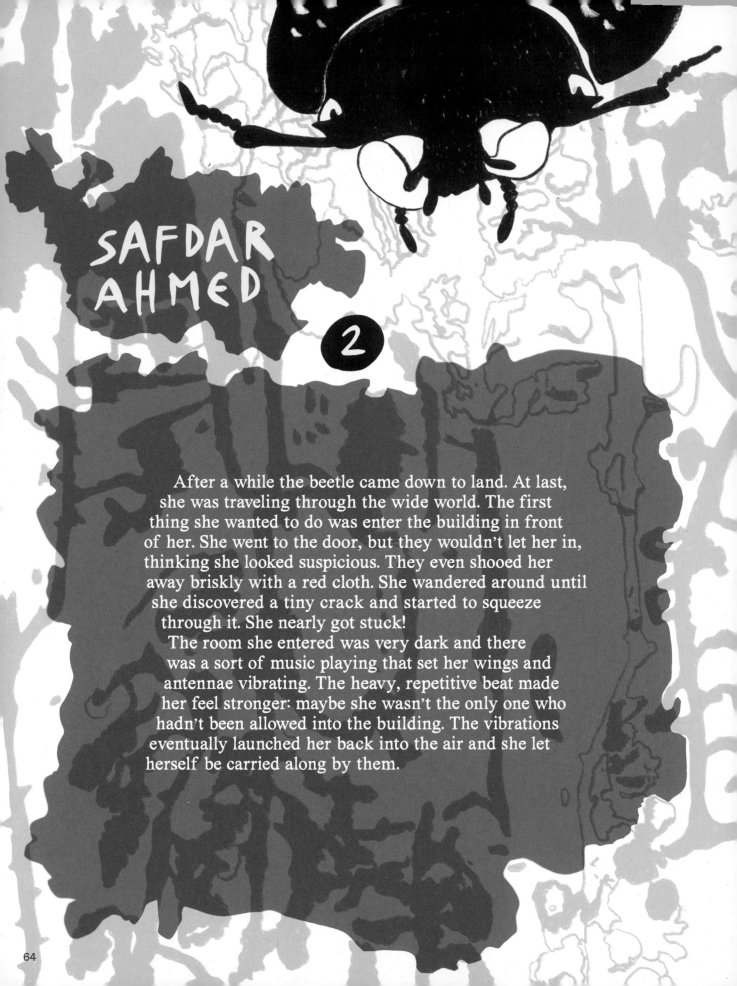

SAFDAR AHMED

2

After a while the beetle came down to land. At last, she was traveling through the wide world. The first thing she wanted to do was enter the building in front of her. She went to the door, but they wouldn't let her in, thinking she looked suspicious. They even shooed her away briskly with a red cloth. She wandered around until she discovered a tiny crack and started to squeeze through it. She nearly got stuck!

The room she entered was very dark and there was a sort of music playing that set her wings and antennae vibrating. The heavy, repetitive beat made her feel stronger: maybe she wasn't the only one who hadn't been allowed into the building. The vibrations eventually launched her back into the air and she let herself be carried along by them.

In the next room there were a lot of drawings arranged on shelves. She conscientiously scurried along every line, every circle. A cockroach that happened to be passing by said, "If you like these 'cosmologies of care,' you should visit the solar forest too. I've just come from there and it's something else." The beetle didn't have any better plan, so she followed the signs.

The solar forest didn't look much like her idea of a small wood nor the thicket that grew around her greenhouse. The light condensed on different sorts of paper had formed bodies and faces. Could it be a sort of human photosynthesis? What would a portrait of the beetle look like among all those brilliant minds?

The beetle flew up to the ceiling to take a look at the solar grove from above and found a spider there, rocking back and forth in a corner. "Hey, you!" the spider said. "Do you want to come with me to the treasure chamber?" The beetle didn't hesitate before saying yes. So the spider wove a small cobweb bag and gave it to her.

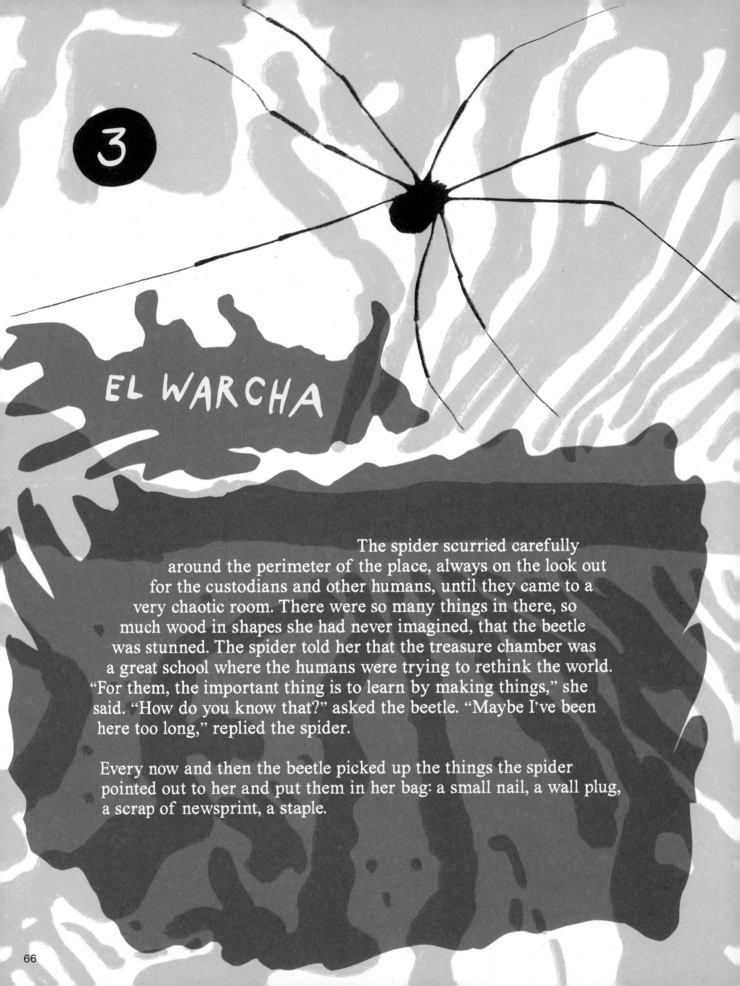

3

EL WARCHA

The spider scurried carefully
around the perimeter of the place, always on the look out
for the custodians and other humans, until they came to a
very chaotic room. There were so many things in there, so
much wood in shapes she had never imagined, that the beetle
was stunned. The spider told her that the treasure chamber was
a great school where the humans were trying to rethink the world.
"For them, the important thing is to learn by making things," she
said. "How do you know that?" asked the beetle. "Maybe I've been
here too long," replied the spider.

Every now and then the beetle picked up the things the spider
pointed out to her and put them in her bag: a small nail, a wall plug,
a scrap of newsprint, a staple.

They went on to another
room within the treasure
chamber. "This is Redeyef," the spider
commented. "It's a weird archive of shapes,
echoes from a past time." The beetle didn't
understand any of this, but enjoyed hearing the
spider's inspired words. "We make a great team.
Wouldn't you like to stay with me here in this space and
time where everything is being reinvented?" asked the spider.

The beetle wanted to stay, because the spider sounded so
metaphorical, and she'd have liked to learn how to speak that
way, so she thanked her but said she was going to see the
world. "Don't forget that this is where the thread of a story
starts, and you can return to it any time. Your story, our
story," recited the poetic spider in a cryptic tone, before
they shared out the booty. The beetle only accepted the
scrap of newsprint and half a wall plug, because she thought
they would be of interest to her community, especially her
father and mother. She put them in her cobweb bag, tied it
around her body, and set out on her way again.

INSTITUTO DE ARTIVISMO HANNAH ARENDT

To avoid any more problems at the entrance this time, the beetle flew over the building until she found a way in. A beautiful pigeon was standing on a window ledge, looking at her out of the corner of her eye. The beetle entered through a crack and smiled when she saw the drawings painted on the wall. Mrs. Pigeon was very big and wouldn't fit in the crack, but from outside the window she called, "The character in the mural has a body made of bricks." "What's a brick?" the beetle called back. "A very human object—hard as stone and geometric, like their minds. They use them to build their nests and other shelters," she replied. "And what's happening to the brick character?" the beetle asked again. "See how with every step its body gets harder, it's losing its extremities, its mobility. It's becoming a wall!" Looking at those images, the beetle thought that she never wanted to become a motionless wall. And maybe that was exactly why she'd left her home. When she turned to thank her, Mrs. Pigeon had already gone.

WAJUKUU ART PROJETS

WAKALIGA UGANDA

The beetle was so excited by what she'd seen so far that she began to make plans and think about how to call an assembly, or several assemblies, to inform the other beetles of everything that had happened. Instead of learning to write in beetle (which she wasn't good at), she could tell stories and perhaps make up a few more. But to do that, she had to pay a lot of attention to the details and try to memorize everything. For the moment, the sun was still shining far above, so there was time to continue her journey and collect more adventures.

*This is a good moment to look for a lovely spot to eat your lunch beside the river or, as our heroine will, in a cafeteria.

It was time for something to eat. The beetle flew quickly to the river and arrived safely in a cafeteria. She found a little cooked rice on a dirty plate and put as many grains as she could into her bag. She added a little piece of apple and another of cucumber, then she settled down on a small sculpture where she thought no one would notice her. The sculpture looked like a tiny tree, except it was made of something different from wood and leaves. She took out all her food and enjoyed her feast. There was a friendly atmosphere in the cafeteria, and the jingles on the television and the laughter kept her entertained. But then a human discovered her and shooed her away with a cloth. "Ugh, these cloths!" she thought. She flew to the sink to escape, moving very slowly after her big meal. At that moment, another human turned on the water and the little beetle went down the drainpipe. She was washed at great speed through other pipes. But luck was on her side; she managed to get back to the surface through the drain of another sink. For the first time in her whole journey, she was afraid—and she was soaking wet. Plus, she'd lost her little bag of treasures. She felt very sad about that, but refused to give up. She could remember all those details, and that would be enough.

AMOL K PATIL

She looked around her and noticed some platforms with wheels, the size of human feet. She wondered why they had a broom beside them. The answer was on a screen. She could see a lot of people using those skates to sweep the streets of a city very different from the one she was exploring. Are they all equal in the world outside the greenhouse? Beetles have different jobs, she thought, but they enjoy the same conditions; that didn't seem to be the case for humans. It was also strange that a screen was answering her questions and even stranger that those people were there inside it. It was almost magical.

SA SA ART PROJECTS

There
were a great many things the beetle didn't understand.
She decided to collect all her questions together and think
them through later. But did she really have to understand
everything? What could she make or say to understand the
humans better? What do we need in order to talk to each
other? She'd started her journey without a clear plan,
emboldened by the uncertainty and the excitement, and
she'd taken her decisions as she went along.

SERIGRAFISTAS QUEER

Next she came
across a sort of tent.
A lot of squares with
different symbols were hanging from posts. After looking at them
for a while, she noticed that the symbols were repeated. They were
very different from beetle writing, but she thought her father would
have been able to decipher them. Inside the tent, there was also a
group of people doing exercises with their faces and hands. One
made a gesture and the person opposite made another in reply.
She felt like playing and learning that language without sounds or
drawings, so she watched carefully from a distance. It was some-
thing like making a census of gestures. The beetle started to wonder
if there had ever been a game like that between humans and
beetles or between spiders and humans. It didn't seem unlikely.
Witnessing those attempts filled her with ideas and hope.

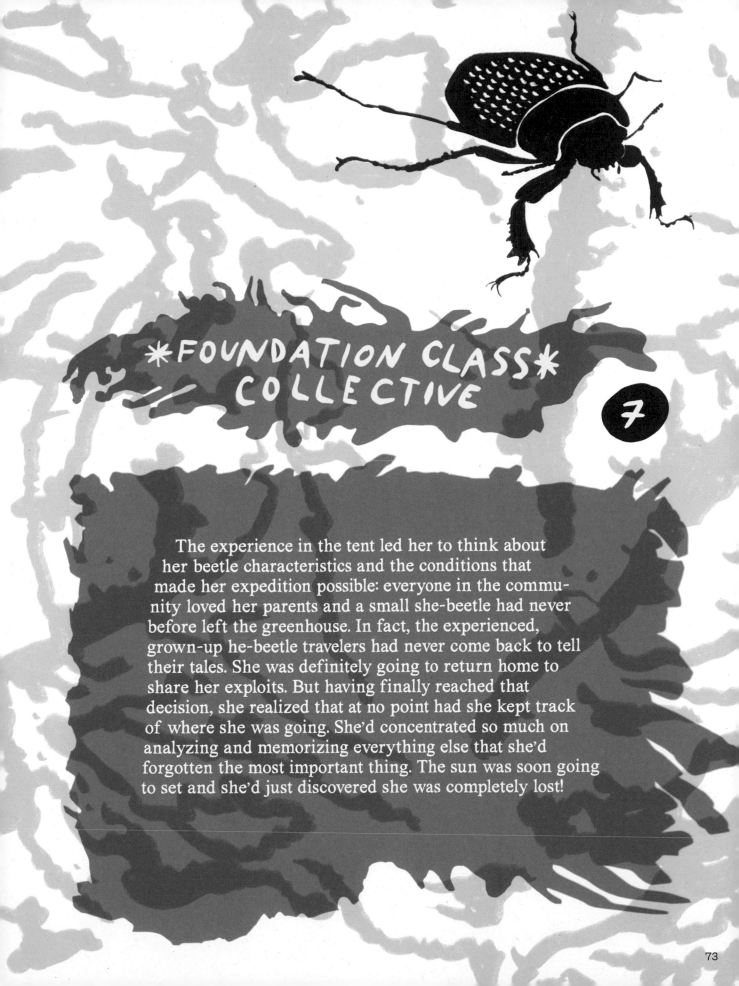

FOUNDATION CLASS COLLECTIVE

7

The experience in the tent led her to think about her beetle characteristics and the conditions that made her expedition possible: everyone in the community loved her parents and a small she-beetle had never before left the greenhouse. In fact, the experienced, grown-up he-beetle travelers had never come back to tell their tales. She was definitely going to return home to share her exploits. But having finally reached that decision, she realized that at no point had she kept track of where she was going. She'd concentrated so much on analyzing and memorizing everything else that she'd forgotten the most important thing. The sun was soon going to set and she'd just discovered she was completely lost!

NINO BULLING

7

Quite unexpectedly, the pigeon reappeared. "Hello again, Mrs. Pigeon," called the beetle, signaling for help. "Why are you shouting? I'm not deaf," she replied. "I might not be a youngster but my hearing is very good and I notice everything. I thought you must be having a problem." Feeling desperate, the beetle explained that she didn't know how to get home. "I'll take you," promised Mrs. Pigeon.

As they were flying together back to the greenhouse, the beetle ran through all the things she'd seen: she wanted to find ways of understanding everything she didn't understand. "We pigeons think in networks," commented the pigeon, unaware that she was interrupting the beetle's thoughts. "That might help you next time," she rounded off. Just as with almost everything that happened on her journey, the beetle wasn't totally sure what Mrs. Pigeon meant about networks, but she added them to the list of questions, memory objects, and stories she was carrying.

The sky between the city's buildings was turning red, the river was tinged with warm colors, and the trees were swaying gently in the breeze. The beetle would very soon be home.

THE END

NOTE:
This tour is a loose adaptation of the story "Thumbling's Travels," by the Brothers Grimm, originally published in 1812 in *Kinder und Hausmärchen*.

TRⲀNSPARENCY TOUR

Welcome to the transparency tour. I'm glad you're here. This is going to be a wonderful journey. Are you ready for a journey? What do you need for your journey?

Here's what I have in my bag: water, some snacks, a notebook, and a rubik's cube in case I get bored. I'll be honest, sometimes I get bored at these things too. That's okay. On this journey, we're going to talk about some things that grown-ups may think you can't understand. Mostly because they are things even grown-ups don't always understand. You have a lot of questions, and sometimes grown-ups feel they have to have all the answers. But let's start with saying it's okay to not have the answers. It's okay to say, I don't know, let's ask. Let's learn together.

By Innosanto Nagara

```
Duration: approx. 1 hr 15 mins
Distance: 5.3 km
```

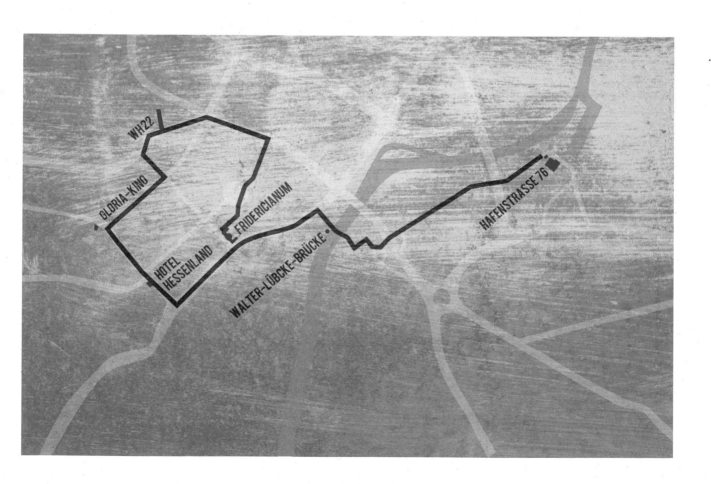

TRANS

Such a big word. Do you know what it means? You probably do know, or at least have an idea. It sounds like it should be about gender and parenting because it has the words "Trans" and "Parent" in it. It could. That's definitely one way to think about it. It's a creative way to think about it, and that's what this is all about so let's keep that idea too. What other things come to mind when you hear "transparency"?

By the way, I ask a lot of questions. But this isn't a test. There isn't a "correct" answer to my questions. I just want to hear your ideas.
What other big words break down into fun other meanings?

PARENT
AMAZE CAPABLE EUROPE
SUPERVISOR CATACOMB
FORTUNE ALONE CARGO
RECLINE RANSACK
TRANCE HEATER NOTABLE
STREET
FURNITURE RECOVER
LANDOWNER FRYDAY
THUNDER REPAIR
ON BROOM
ANTELOPE MAGNET
BATHTUB STARTLE
AIR SEWAGE

I'm sure you will have many questions along the way, and you should ask them. Some questions, you might want to ask now. Some questions you might hold on to until the end. At the very end of our journey, look for what Saodat Ismailova has created. That will be a good time to ask any questions that have not been answered.

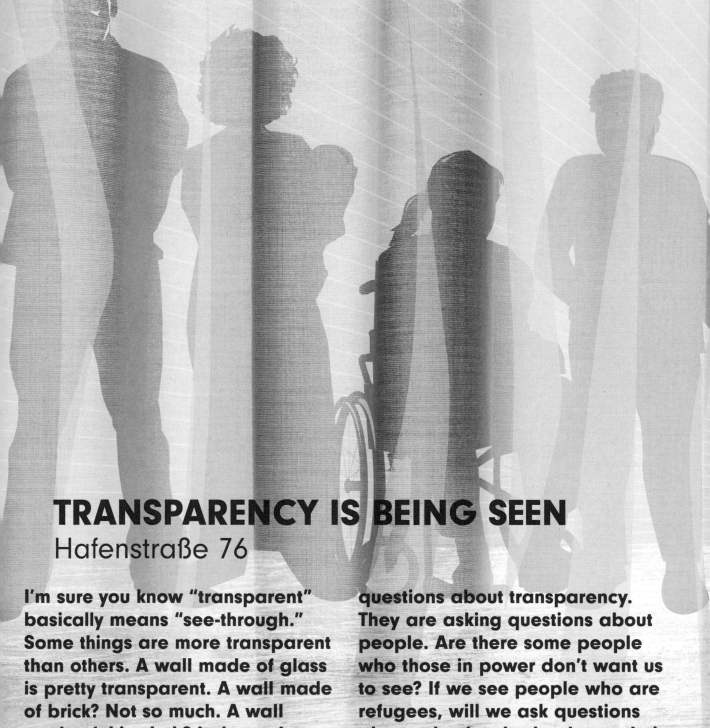

TRANSPARENCY IS BEING SEEN
Hafenstraße 76

I'm sure you know "transparent" basically means "see-through." Some things are more transparent than others. A wall made of glass is pretty transparent. A wall made of brick? Not so much. A wall made of thin cloth? It depends on how close you are to the cloth and how bright the lights are. Try it. If you pull your shirt up over your eyes, can you still see out? Can other people see your face? yasmine eid-sabbagh **is also asking** questions about transparency. They are asking questions about people. Are there some people who those in power don't want us to see? If we see people who are refugees, will we ask questions about why they had to leave their homes? If we hear about people with disabilities will we ask if things are fair? Does everyone get to see people who look like themselves doing the things they want to do?

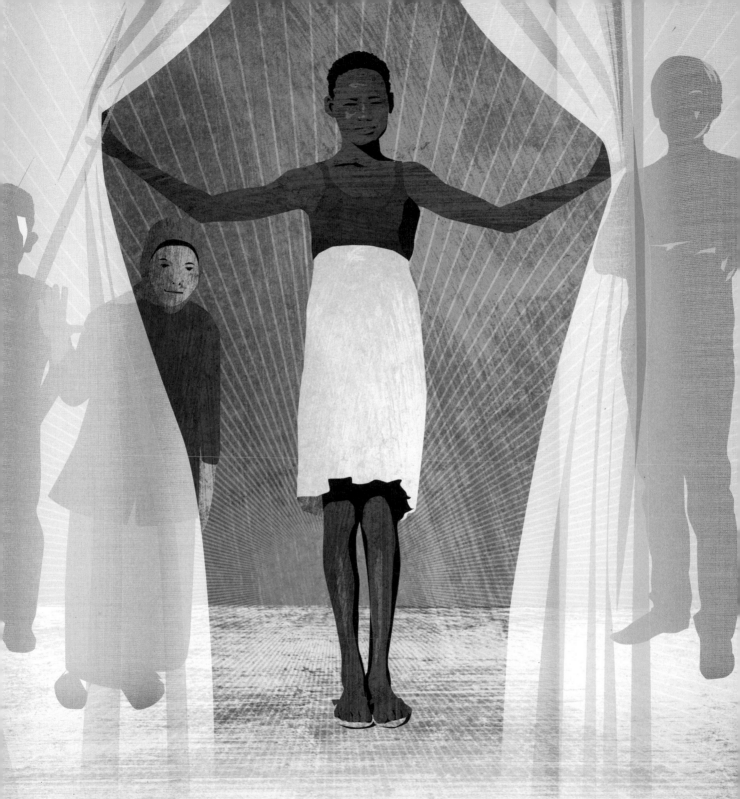

Do people see you?
A question you might ask is,
"Who do you think is not seen?"

TRANSPARENCY IS TRUST
Walter-Lübcke-Brücke

Transparency is also about trust. To trust someone means being able to share with them. If we trust each other, we can share things about ourselves. We can be transparent with each other.
In a community, trust means we can share with our community without fear of losing our share.
When you visit Nhà Sàn Collective that would be a good time to ask questions about trust and community. What is community? Who makes community? How do community members show we trust each other? How is that transparency?

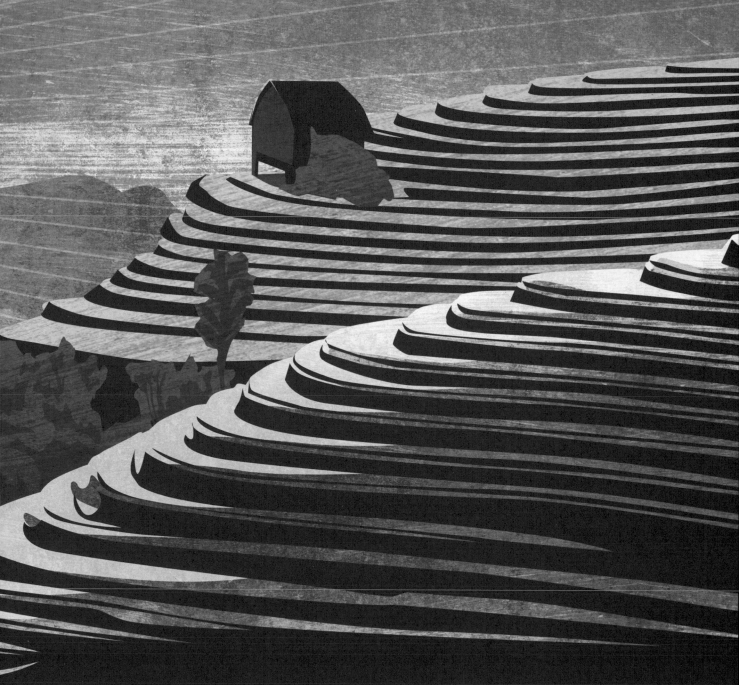

One thing you can ask yourself is, "What communities do I see myself as part of?"

TRANSPARENCY IS ACCOUNTABILITY
Friedrichsplatz | Hotel Hessenland

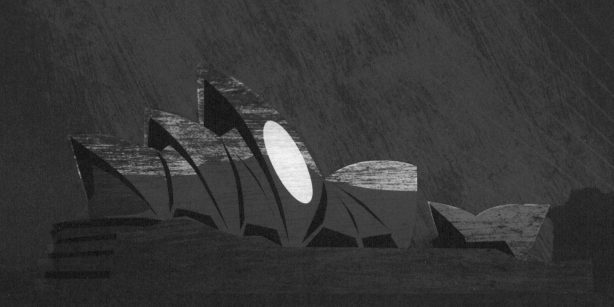

Transparency is also about another big word: "accountability." That means understanding how what we do is connected to others today, in the past, and in the future. When someone does something that isn't right, they need to be accountable. We all have things to be accountable for. When we visit Richard Bell, we can ask what it means when lands are stolen from Indigenous peoples. What it means for those of us who are Indigenous, and for those of us who are not. When we visit MADEYOULOOK we can ask what it means when people from one part of the world try to rule people in another place. And we can ask about how truth can lead to reconciliation and just might allow us to move forward. We don't have a time machine yet (though I'm working on one) so we can't go back and change the past. But we can decide what kind of future we want, and to do that we need to start with accountability. We need to start with asking questions. What have we done right? What have we done wrong? And what do we need to do to repair the damage?

One thing you can ask is,
"What do you do when you've
done something wrong?"

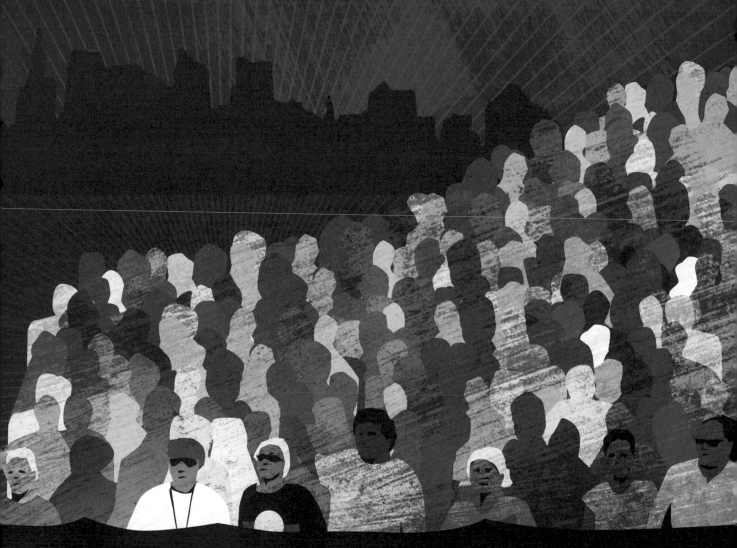

SORRY MEANS YOU DONT DO IT AGAIN

TRANSPARENCY IS HONESTY
WH22

Transparency is a way of being honest. What are the hardest things for people to be honest about? One of them is money. Because a LOT has to do with money. When there is a war, we have to ask about money.

Who pays for the guns? Who makes money from war? Who makes money from an occupation? **When we visit** The Question of Funding **and** LE 18 **let's ask those questions.**

We could ask, "Why is there so much money for guns, but people still go hungry?"

TRANSPARENCY IS POWER
Fridericianum

Why is transparency so important? One way to think about that is to think about what happens when there is no transparency. Here's a story from my life. I'm from Indonesia. When I was a kid, Indonesia was ruled by a dictator. The dictator did NOT believe in transparency. If you wanted to get something done, you always had to give some extra money to the people in power for them to allow it. That's called corruption (or Korupsi in the Indonesian language). And often, the people in power would have secret meetings to plan things so that they could make more money. That's called collusion (or Kolusi in Indonesian). And of course who were the people in power back then? The friends and family of the dictator. That's called nepotism (or Nepotisme).

This went on for over THIRTY YEARS! And they were able to do that because there was no transparency.

But then the people rose up. It was a movement! Students climbed onto the roof of the parliament building and hung banners saying "NO KKN!" They were calling for an end to Korupsi, Kolusi & Nepotisme. And in the end, the dictator had to give up his power.

ruangrupa **from** Gudskul, **who** were students then, were there. And they saw how things changed when the people insisted on transparency. Transparency is powerful. More powerful than dictators.

One thing you can ask is, "Who else is probably afraid of transparency?"

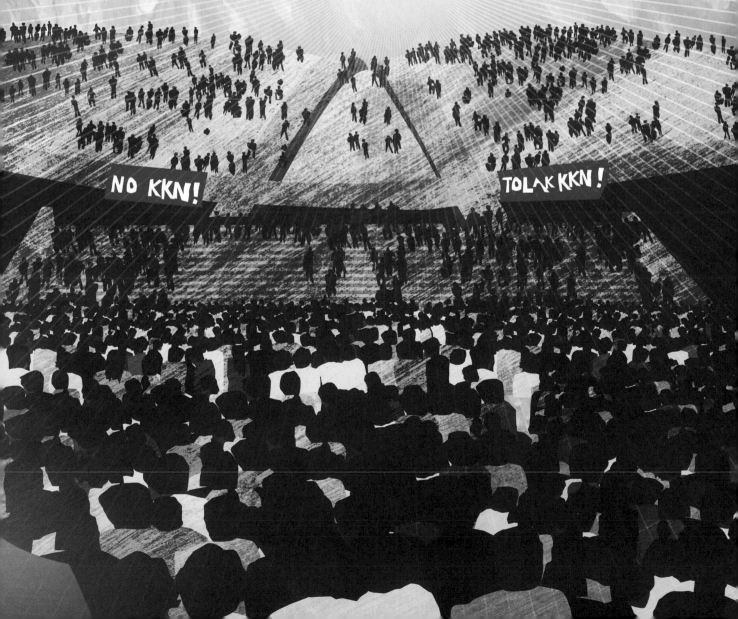

TRANSPARENCY IS INSPIRATION
Fridericianum

This is one of the most important. Transparency is inspiring. It's exciting to understand the power of being seen. It's exhilarating to think of all the things we can do in a trusting community. It's heartening to know that even though we can't change the past, we can take accountability for it and shape the future. It's refreshing to have honesty guide our relationships. And it's inspiring to see how things can change through the power of people standing up together.

When you visit The Black Archives, Asia Art Archive **and** Subversive Film, **don't forget to ask them about the stories that they have to tell. From Hong Kong to Palestine, from the ending of Apartheid to the Arab Spring, today's movements inspire our tomorrows.**

Here I would like to ask you, because you are the ones who will shape the future: "What do you think is next?"

EPILOGUE

When you arrive at Saodat Ismailova we are at the end of our journey. Here you will find ideas that are beyond this world. Do you remember your questions from when we started? I'm looking forward to hearing them!

APP—e—NDIX

AUTHOR BIOGRAPHIES

CARMEN JOSÉ is an illustrator, educator and activist interested in questioning processes of visual representations. In her practice she aims to facilitate spaces for dialogue and coming together. She is a lecturer and researcher in illustration and social practice at WdKA and belongs to the collective Feministas en Rotterdam.

JULIA KLUGE was born in 1989. Today she works as a freelance illustrator in Leipzig, Germany. She studied illustration with Professor Georg Barber/ATAK at Burg Giebichenstein University of Art and Design in Halle and her Masters in Illustration with Professor Henning Wagenbreth at the University of the Arts in Berlin. Her work is exhibited and published in books including, *Zwischen den Zweigen zwitschert ein Waldhorn* (Rotopol, 2017) and *To Be a Brave Scout* (Rotopol, 2021), as well as in magazines.

NADINE REDLICH is a cartoonist from Düsseldorf, Germany. She has published several books including *Ambient Comics* (Rotopol, 2017), Paniktotem (Rotopol, 2016), *I Hate You – You Just Don't Know It Yet* (Rotopol, 2018), and *Stones* (Rotopol, 2021). Her clients include *Die Zeit, The New York Times, Süddeutsche Zeitung, Google,* and *frieze.*

MALWINE STAUSS is an artist and illustrator based in Leipzig, Germany. She studied graphic design at the Academy of Fine Arts Leipzig, Germany from 2013 until 2019. In addition to working on exhibitions and illustrations, her books include *The Trip* (Colorama, 2020), *Hexen* (Rotopol, 2021), and *Sola* (Rotopol, 2022). Malwine is part of SQUASH comic collective, founded in 2018. Together with SQUASH she organizes the Snail Eye Cosmic Comic Convention in Leipzig.

RITA FÜRSTENAU is an illustrator, author, as well as publisher of Rotopol, the publishing house for graphic storytelling. In addition to her artistic and publishing activities, she teaches at the children and youth art school in Kassel and as a guest lecturer in the fields of illustration and graphic storytelling at various universities. Her own works are published at Rotopol in the form of books, folded booklets, and printed stationery.

ROTOPOL is an award-winning publishing house for graphic storytelling touching upon the borders of what illustration and comic art can accomplish. Its range of products lets the reader discover high quality books by as artists with personal styles and stories. In 2007, they established headquarters in Kassel, Germany, from where they collaborate with an international network of comic artists and illustrators. Rotopol brings together creative potential, developing it and making it visible in multiple ways. Next to the publishing office in Kassel Rotopol runs a bookstore with a wide range of picture books, comics, graphic novels and zines.

ISABEL MINHÓS MARTINS
Author and responsible for text contents at Planeta Tangerina. Graduated in Communication Design (Lisbon College of Fine Arts). Among others, she won the Author Awards for children's literature SPA/RTP (2015), the Gustav-Heinemann Friedenspreis (2017) and the Deutscher Jugendliteraturpreis (2017). Her favourite prize was collective: when Planeta Tangerina was distinguished as Best European Publisher for Children in Bologna Children's Book Fair in 2013.

BERNARDO P. CARVALHO
Author and illustrator. He studied Communication Design (Lisbon College of Fine Arts). In 1999, he co-founded Planeta Tangerina where he's been working ever since. He has received a variety of prizes and recognitions for his books and illustrations, including the Opera Prima and Non-fiction Awards at the Bologna Children's Book Fair, the Portuguese National Illustration Award and the Gustav Heinemann Peace Prize. His work has been published in many different countries.

JULES INÉS MAMONE (FEMIMUTANCIA)
is a non-binary cartoonist from Argentina. They have contributed to different fanzines and publications since 2017, including *Clítoris, Poder Trans, Antologia LGTBI, Pibas, Superbollo, Strapazin,* and *Kus! Queer Power.* They are the author of the graphic novels *Alienígena* (2018), *Piedra Bruja* (2019), *Banzai* (2021), and *La madriguera* (2022). Winner of the PROA Award "Todos los tiempos, el tiempo" (2020), they were guest speaker at Medellín's Book Festival, Colombia (2021). They are currently working on their latest graphic novel that will address the subject of mourning and motherhood.

VERÓNICA GERBER BICECCI
is a visual artist who writes. Her artistic quest—the overlap between the word and the image—began with *Diagramas de silencio (Diagrams of Silence),* an exercise in the visual exhumation of the punctuation of various poems and *Mudanza (Moving Out),* a collection of essays about writers who abandoned conventional literature to become visual artists.

INNOSANTO NAGARA
Originally from Jakarta, Indonesia, Innosanto Nagara is a graphic artist as well as an author and illustrator of social justice themed children's books. His first book, *A is for Activist* was a surprise bestseller and since then he has written numerous books for a range of ages. Some, like *My Night in the Planetarium* and *M is for Movement* are set in Indonesia but are about experiences that kids all over the world can relate to. Others, like *Counting on Community, The Wedding Portrait,* and *Oh, the Things We're For!* speak frankly with kids about the challenges we face, and what a positive future might look like.

COLOPHON

WALKING, FINDING, SHARING
A graphic companion to documenta fifteen

documenta fifteen, Kassel
June 18 – September 25, 2022

Artistic Direction
ruangrupa
Ade Darmawan
Ajeng Nurul Aini
Daniella Fitria Praptono
farid rakun
Indra Ameng
Iswanto Hartono
Julia Sarisetiati
Mirwan Andan
Reza Afisina

Artistic Team
Gertrude Flentge
Ayşe Güleç
Frederikke Hansen
Lara Khaldi
Andrea Linnenkohl

Artistic Editor
consonni
Dina Camorino Bua
María Macía Dávila
María Mur Dean
Marta Alonso-Buenaposada del Hoyo
Munts Brunet Navarro

Managing Editor
Petra Schmidt

Graphic Design
Leon Schniewind

Editor
Sofia Asvestopoulos

Student Assistant
Annika Immisch

Authors
Local Anchor Tour
(Rotopol Publishing House)
Julia Kluge
p.12, p.13, p.14, p.17, p.22
Nadine Redlich
p.15, p.19, p.24, p.25, p.27
Malwine Stauss
p.16, p.18, p.20, p.21, p.23, p.26
Concept and Editing:
Rita Fürstenau & Carmen José

Humor Tour:
Bernardo P. Carvalho and Isabel
Minhós Martins (Planeta Tangerina)

Independence Tour:
Jules Inés Mamone (Femimutancia)

Generosity Tour:
Verónica Gerber Bicecci

Transparency Tour:
Innosanto Nagara

Start and end maps of the book by
Carmen José (Rotopol Publishing
House)

Translation
From Spanish
Generosity Tour: Christina MacSweeney

From Portuguese
Humor Tour: Ismar Tirelli Neto

From German
Local Anchor Tour:
Nikolaus G. Schneider

Copyediting
Hannah Young

TEAM HATJE CANTZ

Editorial Team
Lincoln Dexter
Johanna Schindler
Nicola von Velsen

Project Assistance
Yannick Schütte

Production
Thomas Lemaître

Sales
Claudia Squara

Lithography
DruckConcept, Berlin

Typeface:
KG No Regrets Solid – Kimberly Geswein
PP Editorial New – Pangram Pangram
Neuzeit Grotesk – URW Type Foundry
MBI DCMNT 15 – Fabian Maier-Bode
Söhne Mono – Klim Type
Tekton Pro – David Siegel

Paper:
Content – 150 g/m² Enviro Polar
Cover – 120 g/m² Creative Print diamant

Cover illustrations:
Bernardo P. Carvalho
Jules Inés Mamone (Femimutancia)
Julia Kluge
Verónica Gerber Bicecci
Innosanto Nagara

documenta und Museum Fridericianum gGmbH
Friedrichsplatz 18
34117 Kassel
Germany
www.documenta.de
CEO documenta und Museum Fridericianum gGmbH
(Director General)
Dr. Sabine Schormann

Print and binding
Westermann Druck Zwickau GmbH
Crimmitschauer Str. 43
08058 Zwickau
Germany

Published by
Hatje Cantz Verlag GmbH
Mommsenstraße 27
10629 Berlin
Germany
www.hatjecantz.de
A Ganske Publishing Group Company

ISBN: 978-3-7757-5283-1 (German)
ISBN: 978-3-7757-5284-8 (English)

Printed in Germany

WALKING, FINDING, SHARING is also available as eBook:

ISBN: 978-3-7757-5355-5 (German)
ISBN: 978-3-7757-5357-9 (English)

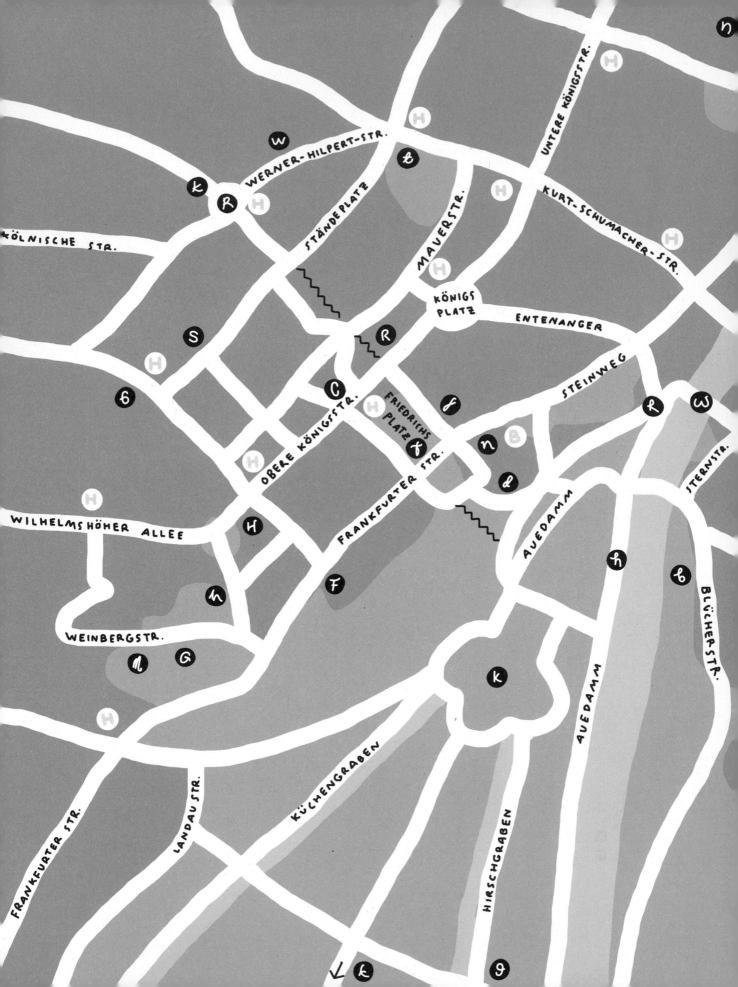